THE STORY OF
FOSTER CARE

EMPTY FRAMES INITIATIVE

The Story of Foster Care, volume one

Empty Frames Initiative
P.O.Box 576
Knightdale, NC 27545
www.fillingemptyframes.org

Publisher's Note: Photo credits go to the individual author of each story and are color coded throughout the book. See the Table of Contents for guide to authors/photographers.

tsk publishing
Barry, TX 75102
www.tskpublishing.com

Book & Cover Design © 2020 Ohalla Productions LLC

The Story of Foster Care/ Empty Frames Initiative

ISBN 978-1-953348-73-9
Library of Congress Control Number: 2020914403

EMPTY FRAMES

initiative

CONTENT WARNING

This book is not suitable for all audiences.

Mature content. Discretion is advised.

This book contains discussion on or examples of:
- alcohol/drugs & drug use
- child abuse
- pregnancy/abortion/childbirth
- trauma
(resulting from sexual,
psychological/emotional,
and physical abuse)
- self-harm/suicide

Some of the following pieces are graphic in nature
and might be disturbing to some readers.

These pieces were included because they are relevant to the discussion.
This warning is provided because we want every individual who reads this
book to be prepared and aware of what they are about to read.

DEDICATIONS

To my siblings: Philemon, Loreal, Elijah, Jeremiah, and Nehemiah who unknowingly motivated my initial drive to succeed beyond statistics.

To my mentors that made an impact by introducing me to programs, nurturing, igniting hope, giving real support and encouragement when in Care: Corey Nixon, Dr. Regina Gavin-Williams, Liza Weidle, Joy Ivy, and Brandi Lyons.

To all youth in care that have forgotten that they are special, that they matter and that they can accomplish far more than they have ever deemed possible.

Your story is a PART of you, but your story is not ALL of you. May you overcome the most unspeakable of battles internal or external.

May you jump out of survival mode and into thrive mode.

May you embrace the world's ventures with an open mind, an open heart and an open mouth to scream upon the highest mountain, share your unique stories and fulfill your desired purpose.

~Angela

My section is dedicated to my mom Virginia Coleman for her introducing me to the world of "foster care", in memory of my dad James Coleman for always having a listening ear.

To amazing professors and mentors that offered encouragement and inspiration.

Most importantly to Christ for covering me through my professional journey and the many youth who are or were in foster care that are the impetus of inspiration for my passion and dedication to social work as a career.

~Carmelita

My pieces are dedicated to my partner, Justin, who has been an unwavering support and reprieve in the difficult moments.

I also value the support and love from my family, friends, and co-workers.

To the youth I've been honored to know in this journey, you have inspired and driven me with your strength, humor, and resilience.

To the readers, I hope this honest and emotional portrayal of foster care doesn't dismay you, but rather provides a genuine depiction of what it means to collaborate with and support individuals within this system, igniting a passion within you.

~Danielle

To my future self and my son, be better than before and always be yourself.

To all of my support system, you are the reason for me becoming better and not letting my past dictate my future.

~ D.J.

To Josh, Julianne, Lydia & Andrew.

I thank our Father for each of you and pray He does even greater things in and through you.

~ Jason

For my little ones - Who require me to be a parent that seeks hard after Him.

~ Kelly

To the authors of this book - you are incredible.
For my husband, who always supports and loves so well.
Thank you for continuing to trust the Lord as He calls us to the next new adventure.

~ Crystal

My contributions are with thanksgiving to those who have helped me to fill my Empty Frames;

For those of my youth: The church family of my childhood. CPS Workers: Tonya, Teri, Lisa, Sabrina. Juvenile Court: Probation Officer PJ & Judge Williams, Counselor Natalie Doughty. My foster family of Chris & Wayne Bartlett, Nick, Melissa, Emily, Whitney. The nurturing of Jackie, Anthony and Jessi. Nancy & Gary for helping me with self-efficacy (employment). Ms. Phillips for help with a place of sanctuary (housing).

For the people whose names I can't remember but faces I'll never forget.

For my parents and grandparents who show up with the courage to rescript our relationships. For my siblings Benjamin, Isaac, Josh and Rachel and their 13 children, who make me happy.

For my friends who journey alongside me: Bien-aise, Cindy, April, Benita, Janelly, Kevin, Kippy, Lauren, Nikki, Raechel, Vusi.

Most of all, for foster youth who have yet to fill their Empty Frames, the best is yet to come.

~With love, Sarah

To those whose stories have not yet been heard on this side of eternity and to the One who always listens.

~ Miriam

WRITING THIS BOOK

Empty Frames Initiative seeks to empower orphaned and vulnerable youth as they age out of state care. Within that objective, EFI began developing a storytelling curriculum for youth to tell their stories and write the next chapters of their lives with confidence. To learn more about Empty Frames Initiative, please visit us online at *www.fillingemptyframes.org.*

The *Storytelling Through Photography* curriculum created by EFI utilized documentary style photography techniques and incorporated journal styled writing in workbooks.

To pilot the first version of the curriculum, EFI sought those who had experiential knowledge of the foster care system. We surveyed people that previously lived or worked within the foster care system, several of whom agreed to not only take the class, but to also assess the effectiveness and give invaluable feedback on the flow of the curriculum. The classes were divided into like-groups and were intentionally small in size. Each group met daily for intensive 3 and 4-hour sessions over the course of a week or more. The classes explored the concepts of using photography as a medium and storytelling as an opportunity.

One tangible result of those sessions is the publication of this book.

There are many misconceptions about the process of foster care and those who are in the middle of it. Even people who work with this population cannot fully comprehend what happens day in and day out of the lives of the youth living within the system of substitute care.

Though this book was created to be helpful to the reader, the exercise itself was also beneficial to the writers. As memories are written down or spoken out loud, there is inevitable internal processing taking place.

Processing is an essential part of healing. Understanding the story comes before dealing with what happened and gives the storyteller a chance to move forward or perhaps even find strength in the history of our own lives. Therapeutic experiences like this activity and counseling could certainly help with gaining understanding, but there are many other avenues and available tools. Time and opportunity are required regardless.

The foremost objective of this book was that the control of the narrative was shared by those who experienced these events. Of course, a book written solely by foster youth or solely by social workers would be worthy of time invested; but a purposeful design using a collaborative effort of foster care alumni, social workers, and foster parents allowed the story to have a richer and more meaningful depth.

We truly believe the people who participated are some of the best in their category - foster parents who love well, social workers who are dedicated and compassionate, and foster youth who are courageous about sharing their journey and acknowledging that they offer so much beyond the experience of life in care.

The time spent with the authors of this book was humbling. Opportunity to voice experiences and be understood by someone else with shared experience, insight into what could be made better, sorrow over things that once were, and joy over what can someday be. Wrenching and beautiful.

May of 2019, we began showing an abbreviated version of this book in the form of an art gallery. Several photographs along with their stories toured our local community in Raleigh, North Carolina. The audience response was overwhelmingly positive, leading to additional shows and opportunities to share more stories.

This is the first of many *Storytelling Through Photography* sessions, the first of many galleries and hopefully the first of many volumes sharing voices ready to be heard.

~ Crystal & the Empty Frames Initiative Team

This book was born from the deep conviction that each individual's story is important. Every individual carries a story that is unique to their life and circumstances. There are moments when our stories converge in the same place. As we enter that sphere, we have to choose between acknowledging that everyone else has an individual story or we choose to believe the assumptions from an imagined backstory we create in our minds and assign to the lives of others. Nothing we imagine would truly reflect another's experience or growth, much less fully understand another's heart.

As a believer, I feel that we *must* choose to let each story keep its individuality. The stories can't be tangled in our minds or hearts. With each soul we encounter, we must begin again while growing in our understanding of this world and its circumstances. In order to keep each story separate, we must allow ourselves to listen again, letting in emotion that comes with each story. It's hard, but it's important, and it's a part of our calling as the body of Christ. In order to love the Lord our God, and in order to love our neighbors as ourselves, we are asked to love as we have been loved (Matthew 22:37-40; Colossians 3:12-13). Thankfully, the Lord knows every story and He is not overwhelmed (Psalm 139, Luke 15:10). I believe that if we ask Him, He wants to give us eyes to see as He does (Ephesians 4).

Thoughts like these led to Empty Frames Initiative. Originally, Empty Frames was the idea of photographing adoptions. Then it grew into the idea of teaching photography in orphanage settings abroad, imparting not only a life skill, but a deeper understanding of soul, self, community, and advocacy. Each person is unique, gifted, and called. How amazing would it be if every individual being raised in state care systems was encouraged in their enormous potential as a child of God? While trying to figure out the logistics of such a venture, I encountered another world — the community of youth "aging out".

In the U.S. alone, close to 20,000 young adults are emancipated from foster care each year. Thus began **Empty Frames Initiative**. Our organizational purpose is to empower orphaned and vulnerable youth as they transition out of state care. The same heart is driving the organization: loving individuals by reminding them that they are unique, gifted, and called. Giving them a place to tell their stories, so they can process, heal, and become active in advocating if they choose. By the grace of God, we were given the time and resources to pursue this dream.

The Story of Foster Care is our first effort to put forward the stories of individuals who have lived out the world of state care. Three foster care alumni, two social workers, and two foster parents piloted our curriculum, *Storytelling Through Photography*, and that curriculum guided the creation of this book. We met with each group separately, in small classes, for a series of intensive 3-hour sessions. We talked about photography and narration but, more importantly, we talked about everyone's stories.

The authors behind these true stories are incredible. They've lived out the ups and downs of state care. Before coming to our classes, they were already advocates in their communities. They loved and grew when things were hard in their lives. I was blessed to have such individuals share their stories with me and blessed further that they would document and allow these pieces to be shared publicly. I truly believe in this meaningful work.

There will likely be a lot to take away from this book. My prayer is that the stories would remind everyone who reads this that their own story is meaningful. That they have the potential to impact the people around them. That their lives have purpose, that every life has purpose. I hope in some way this book points you to the Creator of all our stories and you can find peace in His sovereignty.

**"To Him who alone does great wonders,
For His mercy endures forever;" -Psalm 136:4**

*Thank you for reading,
- Miriam
Founder & Director Empty Frames Initiative*

Photo & Story Credits

 SARAH CHAMBERS

 CARMELITA COLEMAN

 DANIELLE DOLINSKI-SLOAN

 JASON HOSONITZ

 KELLY HOSONITZ

 ANGELA QUIJADA-BANKS

 DESIREA 'DJ' JACOBS

 EMPTY FRAMES INITIATIVE
MIRIAM & CRYSTAL COBB

TABLE OF CONTENTS

PREFACE

Foster care is complicated.

Foster care is complicated because people are involved.

In the United States there are over 500,000 youth in care every day.
Youth who have individual stories and backgrounds that shape their beliefs, emotions, and physical needs.

These stories intersect, merge, blend, and sometimes clash with the life stories and backgrounds of others in their lives, from biological families to schoolmates and teachers to case workers and more.

It's complicated.

We compiled the stories in this book to help bring some of these complicated issues out of theoretical concepts and into real life stories from those who have experienced them. This book was written by seven individuals who experienced the joys and struggles associated with this system: three foster care alumni, two social workers, and two foster parents.

So, while we encourage you to embrace these stories and draw from the experiences of our authors, we also encourage you to embrace the complicated. Embrace the parts we couldn't express in one volume, or even a hundred. The circumstances in foster care will vary dramatically from case to case, and when you encounter someone who has been involved with this care system, don't assume to know the story. Instead, be ready to listen.

Every individual in these writings had different experiences and outcomes, but there were a few key takeaways from every group:

From our Alumni: Foster care was just a part of my story.
From our Social Workers: Everyone can make a difference.
From our Foster Parents: We need more.

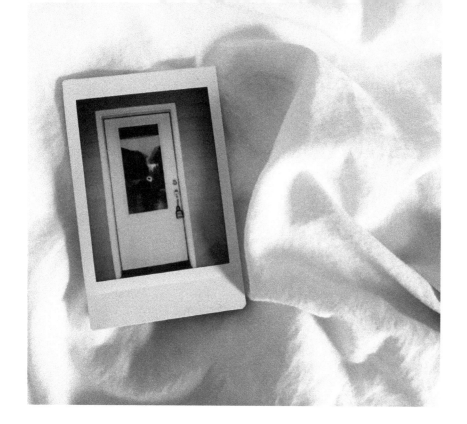

BEFORE FOSTER CARE • PART ONE

Foster care is a temporary, out-of-home
substitute care system.

Generalized sequence of events leading to foster care: crisis strikes a family, a report is made
to Child Protective Services (CPS), CPS may or may not investigate the report, social workers or
other officials may or may not remove the children from the home after the investigation; after
a removal, the case is then handed over to Social Services, Social Services works to help the
child achieve permanency, whether reunited with their biological family or in an adoptive home.

That's the clean-cut, best-case-scenario version of a very complicated system.

Foster care is meant to provide immediate safety to a child in need, while giving the parents a reprieve with specific intentions. The intent is to help. Help parents turn their lives into a safe rhythm that supports their children. The system is not intended to be the dissolution of a family, although that is often an end result. When a safe reunification is possible, it is truly beneficial to the child's health and quality of life. When the family's life is too dysfunctional to support a child, another home must be found, preferably one that will love, encourage, and provide for them.

With over 500,000 youth in substitute care every day in the US, the long ranging list of reasons a youth is removed from their parent's care and placed into temporary care is impossible to generalize. Instead, when looking at the story of foster care, we must embrace the complicated and understand that each removal is unique to the circumstances of each family unit. As a result, although there are a variety of reasons families are reported to CPS and subsequently investigated, the primary cause of removal after a reporting is either abuse or neglect. *see notes end of chapter.*

Everyone involved in the foster care system carries a 'before' story.

Before entering care, the separated youth have their own stories. The "before" might have been filled with emotions like confusion or fear. The youth may have had a perception of normalcy, as sometimes it's hard to see "what's wrong" in a situation that is commonplace for one's reality. They might enter care with nightmarish stories, or they might carry fond memories of their parents or guardians.

Before becoming social workers, the individuals who serve so many carry their own stories. They may have entered this work with a concept of a higher calling, or it may have been an impromptu choice while in college. Their story and decision to pursue this path might include feelings associated with their own childhood, or be based on a memory, perhaps of a friend who needed someone's help.

Before becoming foster parents, the people who care for the children in custody have a story. Common stories are a love for children and community, or a desire to have children. Like some social workers, some stories are based on what foster parents consider a higher calling. On a negative angle, some carry the false conception that supervising children in care would be a means to supplement their income without much thought to the actual guardianship.

To understand the subsequent chapters, it is important to consider the "why". Why did a family get separated? Why does someone want to be in the middle of the mess? Why would someone choose to be involved in such a demanding lifestyle? These are intrusive, deeply personal questions that would likely never be told to a stranger. We hope that this book, and specifically this chapter, will provide some insight into the complicated roots of the story of foster care.

EDUCATION ONLY CREATES A NOVICE

All the education and training doesn't feel like enough when you're tasked with assisting families in the most difficult times of their lives.

You feel unprepared.

You feel small.

Over time, experience can help to build your skills, but even the most seasoned social worker will encounter unfamiliar situations. I try to be a humble learner and make an honest effort to make a positive impact with my clients based on my professional and personal experiences, but I still sometimes experience 'imposter syndrome'.

PROLIXIN'S MAGIC

Before I learned of
dolls, couch-tents, and bed-jumping,
I knew Prolixin.

By earshot, I knew...
sick...Prolixin...hospital..Schizo
Prolixin...kids...sick...cigarettes
bed...money...police...Prolixin.

They are arguing,
too preoccupied to see
me open the fridge
to secretly eat butter
from the bottom shelf
the only one I could reach.

Despite being four,
I knew my mother
could only be my mother
using Prolixin's magic.

A FREE FALL

Foster care, simply put, was not on my radar. I had other plans for my life and I just didn't think it was the right fit for me. But other doors were closed and we were directed down the path to become foster parents.

I would say we 'leaped into this new opportunity,' but in reality, it was more of a surrendering of our own will, and free falling.

Falling into a world I knew nothing about; but seeing firsthand how my world was so vastly different from others. And I quickly realized, I wanted to be a part of reconciling those differences.

TAKE OUT THE TRASH, RECYCLE THE ENERGY AND PLANT THE LESSONS

I came across this, walking through downtown LA after the 2019 New Year. It gave me a range of emotions, from angry to sad, from puzzled and then, disgusted. Yet, I captured that image anyway. I've always wondered the reason why people treat their children poorly or abuse them in various ways throughout their entire life. I had a thought: maybe some people are merely the vessels in which a person is to travel through and molded by the outer confines of one's womb.

Maybe we shouldn't take it personal.

But how can we not when the very same ones who should be protecting us, motivating us, grooming us and celebrating our very existence are the same ones degrading us, hurting us, hating us and sabotaging our will to survive and thrive?

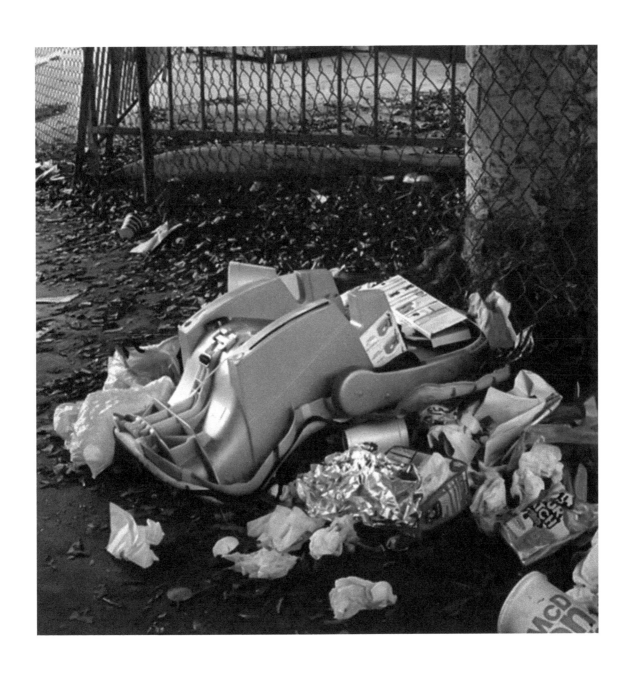

WHEN YOU LEAST EXPECT IT

My wife knew that God was calling us to open up our home to more kids, but I was convinced our two girls were enough.

How could our Heavenly Father make the answer so clear to her while I was convinced of just the opposite?

My heart needed to change. God found me one afternoon in an unlikely place; I was hot and tired, pushing my worn out mower across the lawn. In a moment, He answered my simple prayers. Ever since then, He has been faithful to show me His ways are best. We are blessed.

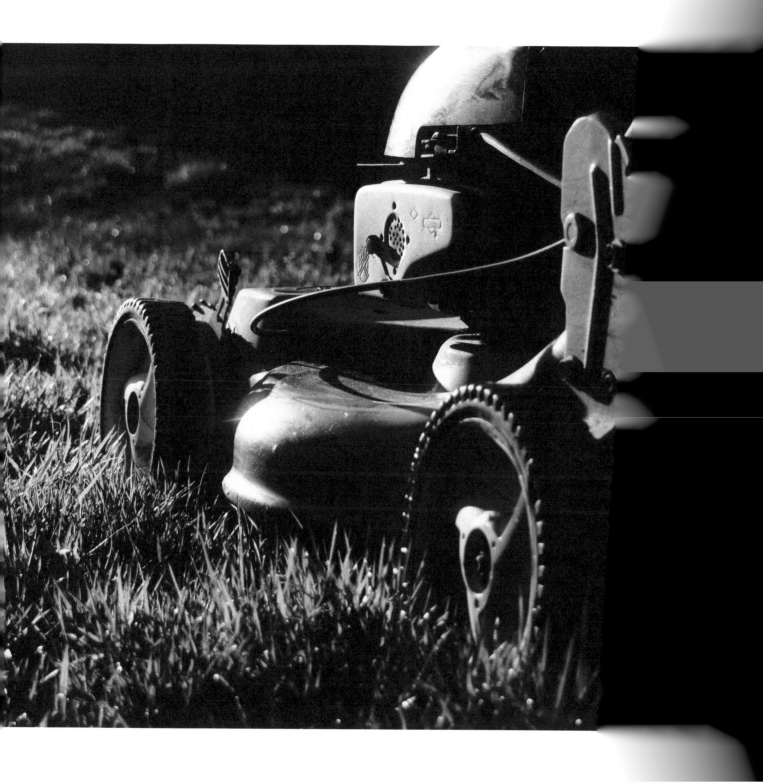

NAME

"Sarah! You can write your name!" the daycare teacher proclaimed, as I proceeded to show her that I could write all 22 letters in my first, middle, and last names. As she continued her praises, I sat biting my lip, because for me, this wasn't a moment of celebration. I knew I could write my name as a result of the many hours spent with a rickety board and broken chalk pieces as my father instructed me on the placement, lines, and angles of letters.

My mother would always remind me exactly why my father taught me to write my name at only the age of 3. "If they ever took you, he wanted you to know your name so you would know where you came from". And take me they did.

My name remains. It holds generational trauma and triumphs between its letters. I've thought countless times about legally changing it. I even thought I would be married by now, to get rid of it. I've struggled across time to extinguish its flames without feeling like I am suffocating myself.

Today, I know my name is woven into the fabric of my identity, a part of the underside of my tapestry, where things are frayed and messy but essential to crafting a new masterwork.

I am the Weaver at this loom and I know the Yarn Spinner.

NOTES

A note on family separation, because this is not a book about the logistical sequence of events and therefore doesn't touch on all the nuances of out-of-home care.

Accidents do happen, false reports are filed, and occasionally, a family is separated without just cause.

Just as tragic, there are children who are physically, emotionally and sexually abused without CPS ever getting involved.

There are families that struggle to make ends meet financially for any number of reasons and leave children hungry, in poverty, and without the most basic needs met, things like clean clothes, a safe place to sleep, even water to bathe.

Some families struggle with addictions that are never recognized nor treated. Some situations have children quietly coping with traumatic events or emotional abuse throughout their childhood, without the hope of healing until well into their adult lives, if then.

Other situations find families homeless. Some parents try to provide some sort of temporary housing for their children on their own, so the family can stay together. However, there are children homeless and living on the streets, far too many to accurately track.

Some families are reported to CPS and an investigation either never happened or after some investigation, the charges weren't substantiated. With the overwhelming number of children in care already, the resources simply don't exist to follow through with investigating every case. And then, some situations are never reported at all.

Unless a radical reversal to the cycle of need and/or abuse happens, how can this brokenness be restored?

Community plays a huge part.

Without a network of support, any family could become a part of the foster care system.

We aren't meant to live isolated and alone. It is unreasonable to expect to meet every need of our own families if we seclude ourselves from others. We need safe connections.

When a child is separated from their family,

it is because a parent or guardian needs an intervention, and that is something in which their community should play an active role. It's imperative to have people who never give up on you. It's meaningful and life giving to have people who believe your family is worth preserving.

That's what foster care is meant to be - a method of family preservation through support - but the sad reality is that the story of foster care often ends quite differently than the goal of reunification.

Every foster care alumni author in our book 'aged out'. This means that reunification was never truly possible and they left the system at the legal age of adulthood without their biological family being reunified and without an adoptive family in their life.

Around 20,000 youth 'age out' every year in the U.S.

As a society, we need to be mindful that around 20,000 families every year need a greater intervention than is currently being provided.

More is needed than the current foster care system if there is to be restoration and a safe connection between the family and child.

The statistics surrounding the consequences of foster care presently should not be viewed as isolated occurences. Statistics such as homelessness, incarceration, substance abuse, and trafficking to name a few.

Unless the children and families are given help, hope, and tools they need to make a positive change in their lives, the cycle of abuse and dependency continues.

Reunification is sometimes completely impossible (save for the divine intervention of Christ) due to extreme abuse or neglect. But the unresolvable cases are not the summation of foster care.

Foster care is for children and foster care is for families. Every soul involved is impacted by the out-of-home care system.

Each of the stories in this book represent instances of lives that weave into the immeasurable network of humanity. You are reading their stories.

You are reading society's story.

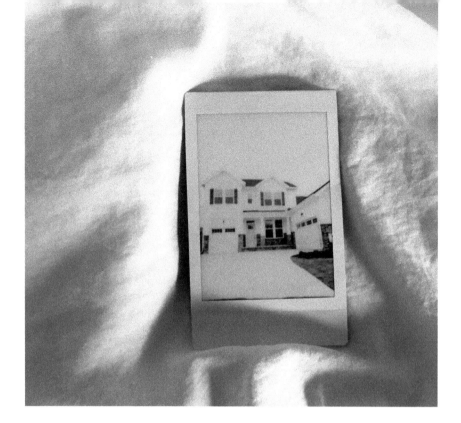

IN THE MIDST • PART TWO

Youth are only meant to be in foster care for short periods, as the ultimate goal is to get them to a safe, permanent living situation.

However, foster care seems to be marked by constant uncertainty for all parties involved. This noticeable uncertainty exists because every action and decision made with each case is made in an attempt to move toward that permanent solution. Unfortunately, the solution itself is often a fluid and ever-shifting concept as opposed to an indisputable goal.

Day-to-day circumstances contribute to determining which route will be taken for each youth's solution, i.e., family reunification, adoption, or emancipation. Everyone involved is mandated to follow a method that will lead to a permanent situation for the youth.

If working towards reunification, the normal route will mean court hearings, visitation with parents, counseling, temporary foster homes. When working towards adoption, the route still includes court hearings, counseling, and foster homes, but also includes increasingly frequent meetings with potential adoptive parents, etc. If working towards emancipation, the route includes the same, in addition to the inevitable shifting of foster homes, guidance meetings, hopefully high school graduation, and the logistics of future living situations.

All of this in the middle of childhood. The youth involved are living in this uncertain evolving state, and social workers and foster parents are trying to check off each mandated appointment amidst school schedules and lifestyle activities, attempting to balance normal life and opportunities within the imperative movement towards permanency for the children in their care.

It's complicated.

For everyone involved, the inability to quickly move children from beginning to end in their foster care journey is perhaps the most overwhelming piece of the complicated puzzle.

The initial trauma they came from, or even the shock of being removed, can be compounded with additional traumatic experiences, worries, and fears the longer the youth remains in the middle uncertain stage, hindering "normal" life moments. Social workers become burnt out emotionally and physically when, despite every attempt to find permanency, the child still remains in transient care and they feel helpless to get them out. Foster parents want to give the youth in their care answers and assurance, when they themselves don't know what tomorrow will look like for the child.

Despite all the problems caused by delayed permanency, it is important to realize that healing can't be rushed, and, for the safety of the child, permanency shouldn't be rushed either. **There is no timeline that will apply to every situation.**

There isn't a long list of people looking and/or qualified to adopt once a family's ability to be reunified has been "terminated" by the court system. Everyone associated wants the process to be neat and tidy; they want the system to work, but the reality is more difficult. The unpleasantness of complications often makes outside forces complacent about the necessity of permanency, a further detriment to those in care.

For the emotional well-being of youth, social workers, and foster families, the middle stage of time in care must remain the middle stage and not the last destination.

The following moments are meant to capture the feelings and common situations of those living in the midst of the journey.

WAITING FOR THE CALL

After we completed 30 hours of training, piles of paperwork, home inspections, medical visits, and fingerprinting, we finally received our foster home license.

Now, we just had to wait for the call.

The call that would change our home as we knew it. A call to tell us there was a child in need of a safe place.

Every night as I went to bed, I placed my phone on my nightstand. I would normally silence my phone, but in this waiting period I left the ringer on in case there was an emergency placement needed.

For those first few weeks, I jumped at the sound of my phone ringing. Would this be the call? Would I be ready?

HOME VISITS

"Home visiting has been a part of professional practice since the early days of charity organizations and today its use is almost universally identified with the practice of social work by the public. Home visits have been made at the discretion of the social worker or they have been made a requirement by law. They have put a client at ease in a familiar environment or have become the necessary part of an investigation process. Home conditions, artifacts and belongings have provided the social worker with a unique perspective into the client's inner world or they have formed the basis of a judgment regarding the income, resources and quality of family life in relation to community standards. They have been viewed by clients as a genuine attempt and willingness to understand, or as a gross invasion of privacy."

Holbrook, Terry (1983) "Going among Them: The Evolution of the Home Visit,"
The Journal of Sociology & Social Welfare: Vol. 10 : Iss. 1 , Article 9.

As social workers most of our time is spent with children, youth and families, doing home visits or being in their home providing supportive services. Most of the homes we visit are like the one pictured here, not knowing what to expect, we take only our work essentials and an open heart, knock on the door and look for the beauty within each person that will be standing behind the door during the home visit. Sometimes we are greeted with a smile from a child, but most of the time an angry and confused adult pondering what will be the result of our visit to their home.

TRUST AND FAIL

One of my first foster homes is where I had my first gun pulled on me and my first sexual assault and rape. That happened while I was in foster care. Basically, it was me asking one of the biological kids of the foster family why people called him "Milky Way" and he went to his room and pulled out a gun and said, "If you ever ask me that again - I will shoot you and kill you".

The foster family used to lock the bedrooms at night, so we couldn't get out, but later that night, he unlocked my room and began his assault by touching me and pulled the gun out again, saying things like, "If you tell anyone I did this, I'll kill you."

Don't be scared to ask questions or scared of what's going on around you. Stand your ground. Don't be scared. Stay strong.

I told them [my foster parents] and I told my social worker.
They didn't do anything after that. They didn't do anything to help me.
They didn't address it with him or anything like that, not that I know of.

I was too naïve before, and then after that happened to me, it was like... "let me pull this back, let me not trust people as easily".

I was 13.

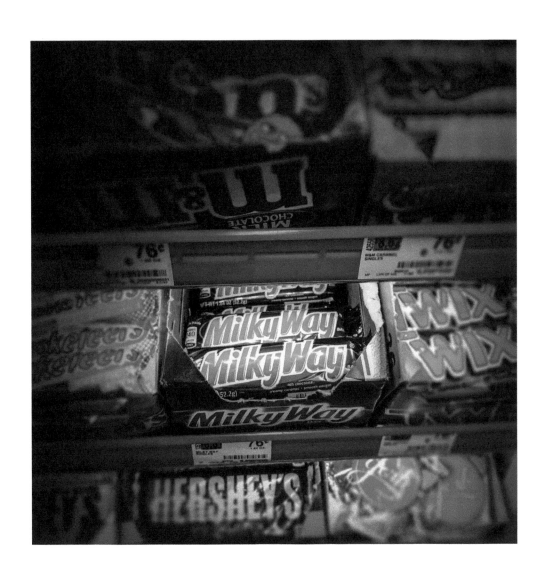

PLACEMENT REALITIES

A single piece of paper.

That was it.

Our first placement arrived to our home with a small bag of clothes and no details.

The little information that was passed along to us verbally, later proved to be inaccurate.

We were left staring at a baby we just met, and wondering how to take care of him.

How can we meet his needs when we don't know what his needs are?

I DON'T KNOW YOU,
BUT I LOVE YOU

Despite their best efforts, the information we receive from case workers has been, at times, laughably incomplete or incorrect. The infant we were expecting was a toddler or the unbearably overweight baby was actually a healthy little boy. The bits and pieces are enough to start forming a connection, though.

By the time they arrive at the door, we don't really know them, but we love them.

PURPOSE IS BEYOND THE PAGES

The paperwork and case documentation required can become overwhelming.

But when my phone rings, my purpose is clear. I endure for my youth clients.

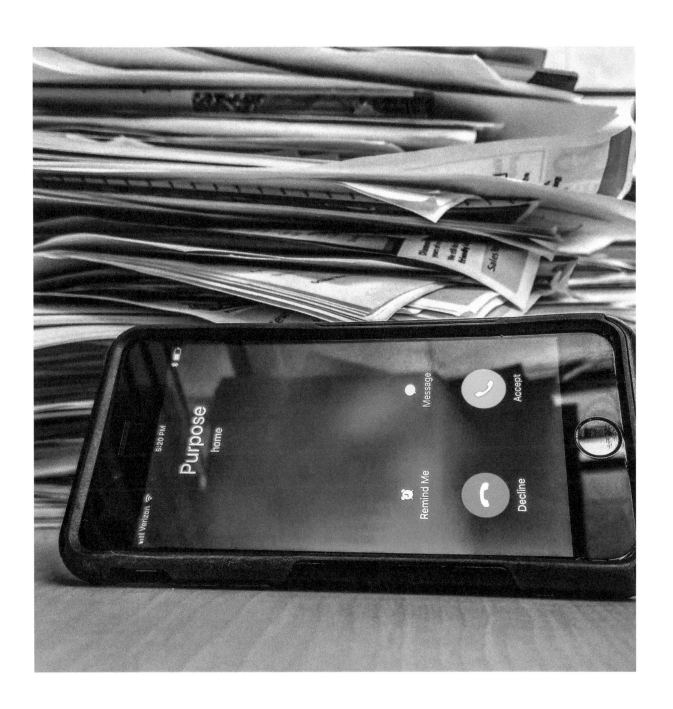

MOVEMENT

I was in 20 different placements in foster care.

I entered when I was 11.

This symbolizes the different placements. They moved me from one home to the next and I adapted to having everything in boxes.

I remember one day I came home from school and I freaked out, getting mad, cussing and fussing, doing everything I could, because the foster mom had unpacked some of my stuff.

I was like "Why would you do that? I don't know when you're going to kick me out and I need to be prepared! I don't need to be stressing about trying to pack - I'm seven months pregnant! I don't need this!" I had a panic attack.

Then both of the foster parents were like, "you need to take it easy, you need to rest." Then Crystal, my foster mom, was able to talk to me because I was so upset, she tried to explain what was going on. She said, "DJ, you know, you're not going anywhere. We're not going to kick you out, you're here for the long run. This - unpacking your stuff - is our way of proving to you that you're not going anywhere."

So we unpacked the rest of the stuff together and got me situated.

I was still upset and said, "You need to consult with me first before you touch my stuff."

I was so used to people stealing my stuff or messing up things that wasn't theirs.

So it freaked me out. But, I think she had good intentions. It was the first time she saw the 'evil side of me'.

Soon, we had everything organized and clean.

Clothes hung up, put in drawers. Bed made. My stuffed animals on the bed.

It was a very significant moment for me. I'd had so many different placements because people didn't want me there, or they just wanted me for the money. People would lie to me. Or it would be like, "I want to talk to you", but they'd make me leave.

There were so many things that took place. At the end of the day when you're moving from place to place you had to keep your stuff packed up. Always.

I always took my clothes out, put them in a dirty hamper, washed them, folded them, then put them back into the box.

That's how I lived for years. The only other place I took them out was with Ms. Stella. I stayed with her for four years. She said, "Why's your stuff in boxes? At least change the boxes out."

It's ok to get comfortable where you are.
It's ok to make home.

Sometimes there will be sudden movements, which may make you uncomfortable, but you'll be ok.

*THERE WERE SO MANY THINGS THAT TOOK PLACE.
AT THE END OF THE DAY WHEN YOU'RE MOVING FROM PLACE TO
PLACE, YOU HAD TO KEEP YOUR STUFF PACKED UP. ALWAYS.*

MEETING NEEDS

I had so many questions about this baby I just met. The answers they gave me were uncertain.

His nutrition was not right and I could see it affecting his development.

I knew he needed formula, but I was told otherwise. I was not comfortable continuing with these instructions.

I was determined to follow my motherly instincts and give this baby what he so desperately deserved...someone to fight for him. Someone to put his needs first and not stop until they were met.

I became that someone for him.

I talked to doctors and supervisors and pushed until I felt satisfied with the answers. I waltzed into Target and bought formula for the first time.

I got his nutritional needs met and felt the confirmation I needed: I can do this.

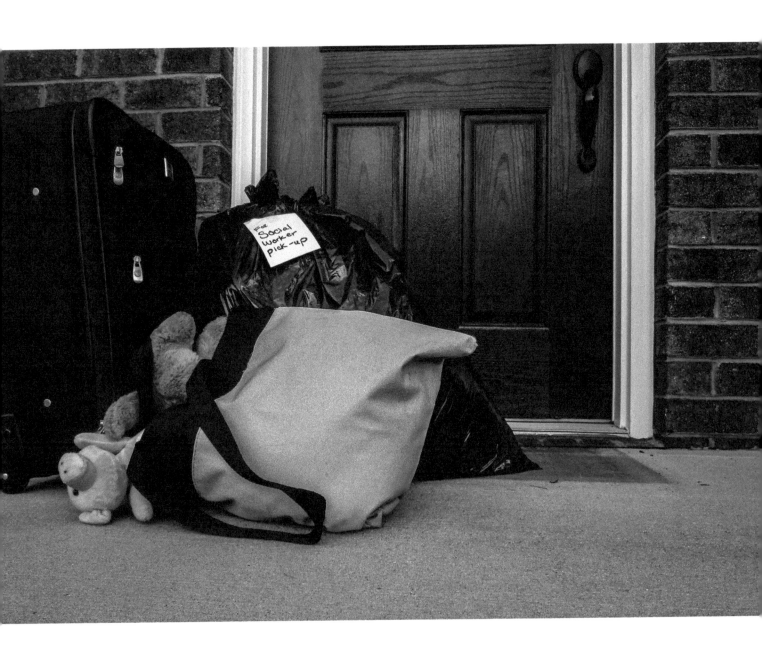

THE DAY I SAW
HIS WORLD SHATTER

When I walked up to the house, I stopped in my tracks when I found it empty and his belongings piled up outside on the porch. I was thankful he wasn't here to see this.

I hoped the conversation of the impending move went well. Things happened so quickly, less than 2 days after we met to try and assist the family. I hoped he was coping with the move, with the news that the adoption wouldn't happen.

After remembering to keep moving, I loaded up his belongings. I went to his elementary school to pick him up. He ran out into the hall when dismissed early. He suddenly stopped 20 feet from me and said "I thought Daddy was picking me up."

My heart ached intensely. I knew it was now my burden to deliver this blow and to minimize the trauma as best I could. I pray he wasn't as affected by this move as I still am.

POTATOES

(A letter to all foster parents that don't understand what it means to actually be a "parent")

How am I any different to you than these sacks of potatoes as a foster kid?

You have a merchant - case manager -, a customer- foster parent or resource parent, and you have an ingredients label in which everyone picks away at you for.

Loving a foster as they are isn't truly the idea. If so, would one have to check the ingredients of who I am based on a bunch of biased strangers who barely took the time to get to know me for themselves? I mean, how is that fair? I didn't see your ingredients label. I didn't get to choose to stay locked away as your secret to help you feel more of a 'good samaritan' because of it.

Foster youth are not your free labor foster slaves. I'd like to invite anyone thinking about becoming a foster parent to really evaluate yourself and your true reasons why you're deciding to take on the task of a foster youth or any youth.

Foster youth are human beings that want normal kid, teenager or young adult lives.

Foster youth, although we have gone through trying events in our lives, don't want to feel continuously stressed, angry, unwanted, or judged for ingredients that have expired long ago.

Why is it still on the file that when we were 5, we kicked another boy in the head? And why wasn't the reason listed? Or why is anything that is in the file not questioned?

Non-Foster-Related people, whether they are case managers, foster parents, social workers, etc., have the ability to lie just as much as foster youth can. More often than not, they have lied to cover their own reputation and the foster youth is the one that has to deal with the newly added ingredient label. And now they are less desirable to a good home. Now they must go to a group home or a less favorable area.

Accountability and unbiased foster youth placements need to be a normality.

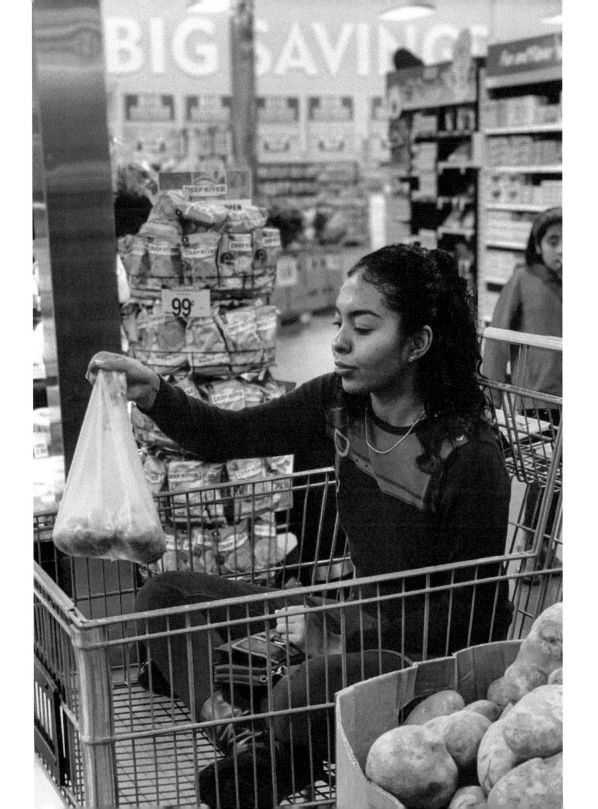

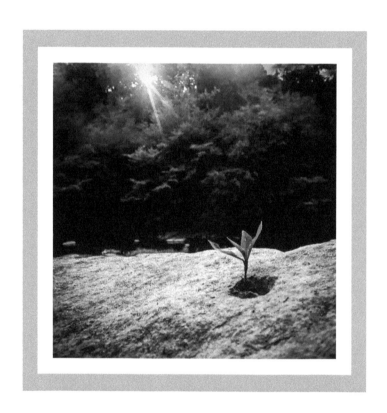

RELENTLESS

MY JUVENILE "JUSTICE"

...and I ran and ran, gathering numerous legal charges for running away and evading police, until it was actually my probation officer who recommended foster care. Not CPS. I waited a month in an isolated cell within a juvenile detention center wondering whether I would be wrongfully incarcerated long-term. I had been sentenced with legal charges related to disorderly conduct and running away, my forms of expressed anger at a failed child welfare system that could not seem to comprehend running away as a byproduct of abuse. After a few weeks, allegations were found to be false, but where was I to go?

The days crawled by until twenty-eight days later, a CPS worker showed up to take me away from one concrete cell to another - a therapeutic foster home. I had been labeled as high risk. Even though I was released from the juvenile center, a toxic fear replaced my faith in justice during those 28 days inside that cell.

Detention cells should never be used to warehouse unwanted children.

WHAT CAN I DO?

I see your...
Tears mixed with rain
Emptiness and pain
Nothing left to hide
All I can do is be there for you!

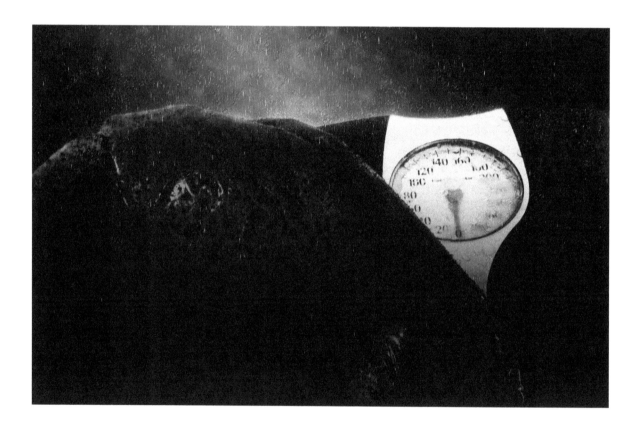

A suitcase in the form of a trash bag.
Ripped, spilled out & wet.
Loss & ruin of the nothingness inside.
What can I do?
All I can do is be there for you!

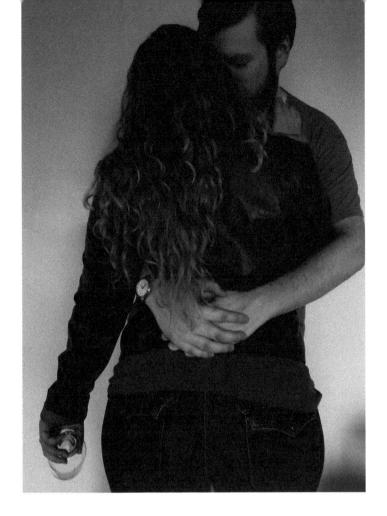

EMPTY GLASS

To My Youth:
I pour into you encouragement, support, and empathy. Your pain and worry are drained into me, and I feel it deeply. I seek to fill you with hope and light, to help you keep flowing forward.

To My Partner:
You fill my glass when it's so often depleted. You too often forgive me when I cannot hold another ounce of compassion. You fill me with love so that I can continue to pour into others. Your support is everything to me, as I continue to strive to keep myself replenished.

HOME

A sip of warm tea. A nice comfy couch. Feeling loved in this space by the people around me and, most importantly, by the soul that resides within this body that makes me — me. Reading books to escape in a vast sea of knowledge or entertainment. Ah. What a life. To feel safe, secure and stable would seem to be a luxury in most confinements within the poverty stricken society and those engulfed within the foster care system. A basic necessity you say? Well, I didn't feel "at home" often at all. In fact, the phrase "make yourself at home" gestures to me a more unpleasant feeling than most common phrases. Maybe because it is so cliché and majority of those that uttered those words to me did not genuinely mean it. Nevertheless, home is a feeling - a vibe. I've come to understand that it is not a place but rather home can be found within a person. I thank the love of my life, Michael, for truly being home to me. Home is not a building. Home is when you know that you feel genuine happiness, a familiarity and undeniable, immense love. Home is a spark that you can't really explain within the pit of your soul that beams brighter and brighter within you and you know that everything - no matter what - will be okay.

Home is a state of mind and a feeling that is given.

Where does it hurt?

Use an "X" to indicate the areas where you are experiencing pain or discomfort.

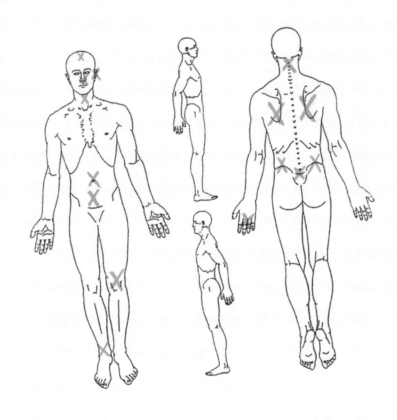

"I wouldn't expect this in someone your age..."
"You usually only see this in people with..."
"You typically only see this in much older people..."
- Healthcare providers when diagnosing a new ailment

THE DEVASTATION OF TOXIC STRESS

Chronic Ear Infections with myringotomy surgery x4.
Childhood Asthma and Allergies.
Endometriosis, Age 13. Urinary Retention, Age 15.
Hypothyroidism, Age 16. Syncope with collapse, Age 17.
ANA+ & Rheumatoid Arthritis, Age 17.
Cervicogenic headache, Age 19.
Cacchi–Ricci kidney disease, Age 20.
Lymphatic Ulcerative Colitis, Age 21.
Chronic C-diff infection >= 1 yr., Age 22.
Spontaneous Pneumothorax x2, Age 24.
Spontaneous pneumothorax x3 Age 25.
Restrictive lung disease, Age 25.

I was determined Disabled by Social Security, Age 25.
My ACE score is 8.
My Resilience score is 9.
I rejected that disability would be the end of my story.

Children in foster care are named by the American Academy of Pediatrics (AAP) to be Children and Youth with Special Health Care Needs (CYSHCN). Specifically, they demonstrate disproportionately high rates of physical, reproductive, oral/dental, developmental, behavioral-emotional, cognitive, educational, and social dysfunction compared to the general child population.

Typically these health conditions are chronic, under-identified, and under-treated and have an ongoing impact on all aspects of their lives, long after children and adolescents have left the foster care system. Pediatric care of children in foster care must be healing centered to meet their medical, mental health, and developmental needs but often improved heath is inhibited by a number of controllable factors.

The AAP Standards of Care for Children in Foster Care endorse an increased schedule of medical visits for important developmental, social-emotional/mental health, educational, and dental screenings that should occur within 30 days of a child being placed into foster care, as well as the enhanced schedule of ongoing well-visits for children in foster care.

To learn more about this important work, visit *www.ncpeds.org/fosteringhealthnc*

OPENING DOORS

You've encountered too many barriers.

I seek to open doors for you, even where you never expected them.

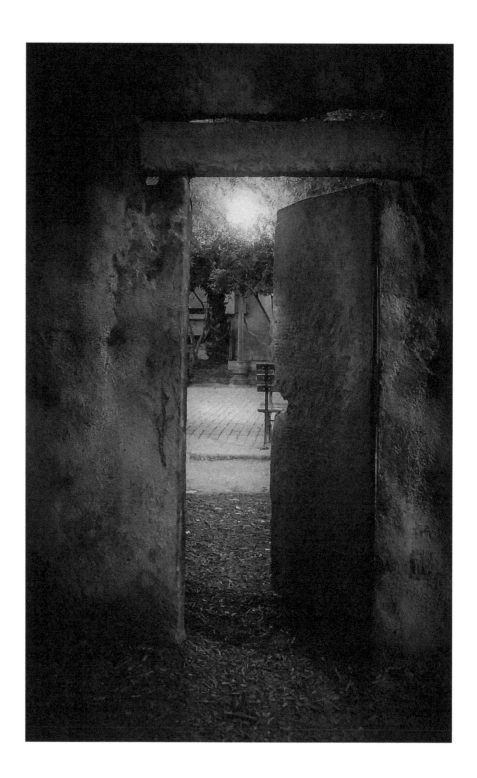

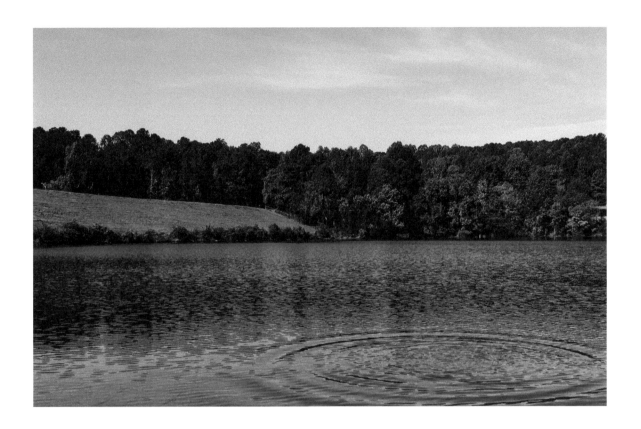

RIPPLES

There is more than all this pain. There has to be a rainbow beyond this rain. All the drops within this body of water all started somewhere. All these rocks that surround my feet, all came from some place. This has withstood father time and clung to mother nature. How do I push through? That is the question, however, you shouldn't be asking me. Perhaps it is a question you should be asking you. You determine which perspective that you want to carry through life. AND YES. It is a choice. Do you truly want to be happy? Or do you want to continue to be seen as a victim?

I think about what I can do now to impact others in my life in a positive way. Why wallow in self pity? Why hold yourself a hostage as a prisoner within your own mind? If I know that life has been rough and I haven't had many people behind me - why count myself out? I learned early that what I do now will effect my future. I understood that I have a purpose and it wasn't to become a failure and die. No, not at all. The question was then - do I want to create the ripples of change within my communities? Or drown in waves of depression and self destruction.

PLANTING SEEDS

Many times during this journey I wondered if we were making an impact. I questioned whether or not the children would even remember being in our home. My questions were answered one day as I heard our foster daughter singing our bedtime song Jesus Loves Me. The often unseen impact lies in those little moments that I took for granted. Those moments when we could pour love and truth into the lives of our children. I realized these seeds that are planted will continue to take root and grow. Even though we may not get to see them bloom, I am confident that those seeds will prosper in the places where they are planted. The time we have together, although short, will be a part of their stories. I trust that their stories will be extraordinary.

CAGED IN CARE

Smile when you are mad.
Take these pills when you are sad.
If you act too bad...
they'll send you away.
Don't be emotional about
your trauma.
Don't cry even if you miss your mama.
Shut up.
Sit down.
Don't complain about their food.
And don't complain if there isn't any.
Wash their dishes.
Don't leave a mess.
Don't tell them too much about
your past.
They'll judge you.
And for Christmas, no one will grant
your wishes.

No, you cannot see your family.
No visitation unless mandatory.
No friends over.
No, you may not leave this house.
It does not matter if you're
making friends and
just want to be normal.

Shut up.
You're talking way too much.
Tell the social worker what's
going on?
Wow. You're just asking for a punch.

Don't yell.
Don't scream.
Don't write it out.
Don't wanna eat 3 times a day.
Don't stay to yourself.

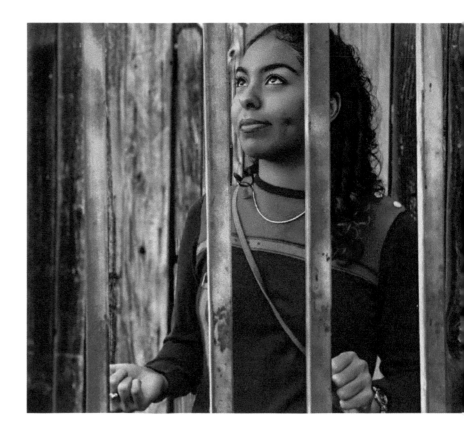

You're selfish.
You're stuck up.
You're ungrateful.
No wonder your parents
didn't want you!

Life?
Just trying to make it
All on your own
Without having to fake it
Do I have what it takes?
How much longer before I age out?
Whether or not it was true...
it doesn't make it okay to have been
said to you.

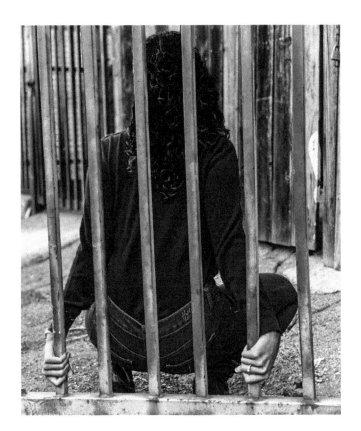

Just focus on healing
and know that we all make
mistakes! It's not a big deal.

The biggest resolution is to learn
from your mistakes, read lots of
books, and ignore all the dirty looks.

Life is hard and harder if you're
a foster youth with limited
supports. That doesn't mean
give up. It just means we have
to try a little harder to build
ourselves up and create a healthy
circle for ourselves. Continue to
perservere throughout any
obstacle that life throws at you.
Go to conferences. Maybe even go
to therapy, talk with some trusted
people and meditate on past
traumas you have yet to heal from.

It will get better, it always does.

I know it may not seem like it,
but everything is temporary.

Your fate is in your hands.
Do what you can to fix it and
disregard what you cannot
because it will only make you
stressed and sick.

You are the CEO of your own life.
It's time for you to own it!

You got this!

I believe in you!

What they say doesn't matter.

They didn't know your story.

Only bits and pieces through a
distorted perception.

They don't know your heart and all
you're destined to be.

And maybe you don't either, but
that's okay if you don't.

One day you will.

LOAD BEARING

When you have to move homes,
I feel I have failed you.
I feel the need to put all of my support
into this placement, so you can have
some sense of normalcy.
Some sense of permanency.

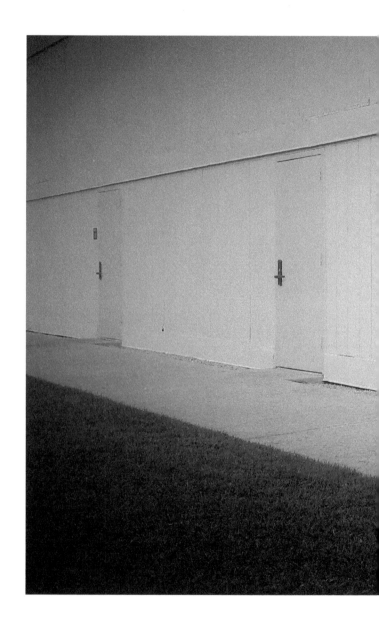

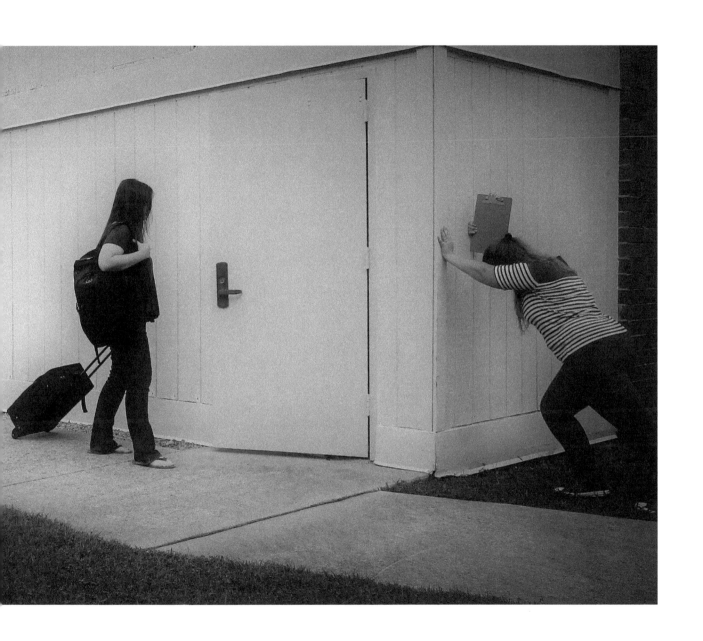

WALTZ
BENEATH
THE WILLOW

I find solace in the
weeping of the willow,
how she flourishes in the
midst of her grief.

Beneath her drooping limbs
I waltz with sorrow dancing
through life in a perpetual
funeral procession
for losses that will never
have a tombstone.

To live with ambiguous grief
in the middle of a blossoming
life is a parallel journey
forever swaying
between the two truths.

How does one mourn what
never was nor will ever be?

The only remedy for the
grief of the mortal heartbeat
is its hope.

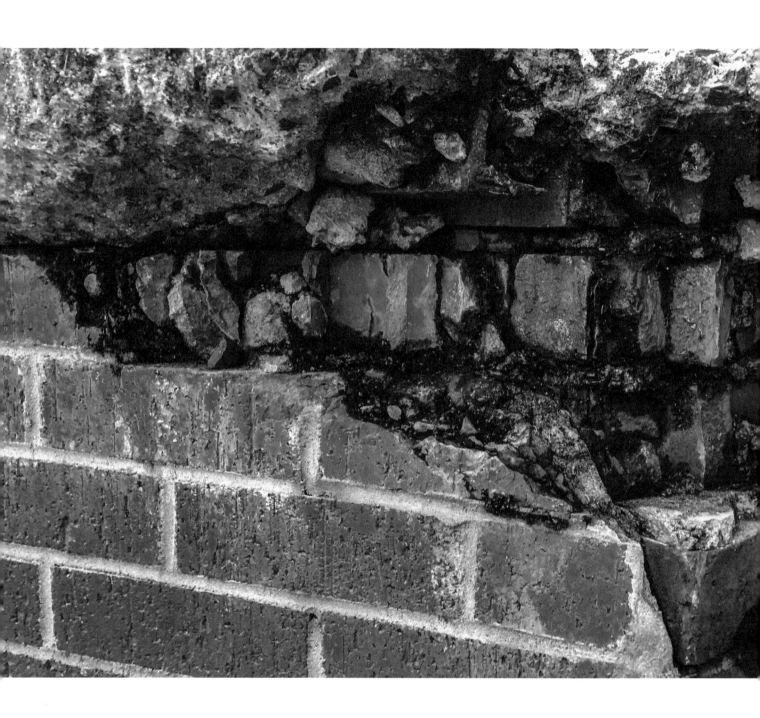

DEFENSE

The reason I chose to photograph this wall is because it symbolizes how I don't trust a lot of people; it's very hard now for people to break that wall down. I like to hold my ground. The part of the wall that is not broken is like a wall to the world, like I don't trust anyone. There are very few people I do trust, which is the wall that's broken. I don't usually give people the chance to break it down because I always find an excuse not to trust somebody. Which I know is bad, but it's also a good defense because I think I know their intention in the first place. I can literally look at somebody in the mall and be like "If I was to talk to them, this...fill in the blank...would be their intention." And I'm not usually wrong. The broken part represents the very few people who have broken my wall down, those I have trusted. Then like the darkness in the wall, the squiggles, those are like the problems and the untrustworthy things that people say and do that I see trying to creep in, get at me, and I have to build that wall back up. It's basically me protecting myself - always - and knowing the difference between 'These people, they're not good for you. But these people are and they're really trying to help you.' But you have to realize that there's dark matter, evilness of the world, trying to seep in and trying to get at me, sometimes using these people that I trust. Like the devil. It's significant because I like to protect myself. I'm building that wall up for me and my son. A'aydin's behind that wall and nobody can get him. I want people to know to stand your ground, be careful who you let in your life, because there are toxic relationships. It's been there my whole life, because my family has done stuff to me too.

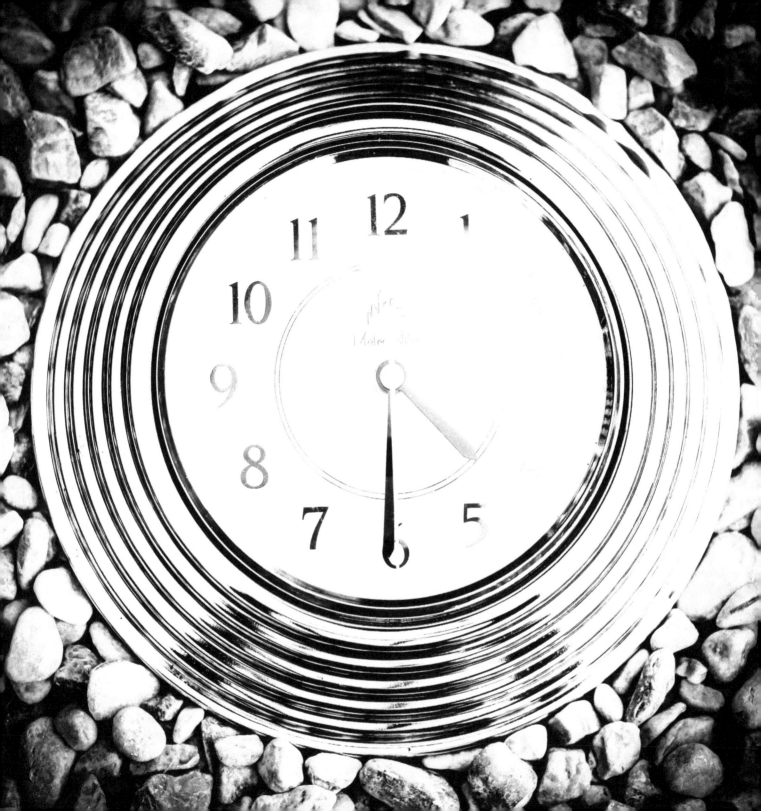

RESPITE FOR MY SOUL

At 16, I went to live with my foster mom Chris after being released from juvenile detention. I had spent years running away in search of change. I've described Chris as a breath of restorative air, air which I had been gasping for my whole life. And then one day like an answer to a prayer that I had almost let go ...there she was, a stranger opening her home to me despite knowing my chaos.

Chris wasn't an especially emotional woman, she passed the time with me playing cards, at times validated my past hurts which I only spoke of when prompted, she gave me quiet comfort and a stability I had never known.

I know what created a shift in me; it was how she invested time in me. I vividly remember her glancing at her clock, preparing to take me to visitation, medical appointments, counseling, social activities. Her actions showed me I was worthy of time and healing.

Today, her clock hangs in my home, reminding me to be conscious of what I choose to spend time in; it is our most worthy resource.

18/SMK

Ms. Stella. The one and only.

She was my 18th placement.

I moved with Ms. Stella October 20th, 2010 at 3:31pm. She was awesome and still is. She took me in and life changed for me. Again, discipline. She was not one who took backtalk. She will always be my mom, no matter what. She never gave up on me. She wanted to adopt me, but my bio mom wouldn't sign over the parental rights. I stayed with her for four years - until she moved.

The longest foster she had before me was three years. She told me, "No one's ever stayed with me this long. They usually get sick and tired of me or something."

I started going back to church. I learned what love was. That lady did everything she could in her power to make sure I was ok. She helped me get my first job. She taught me how to budget (I wish it would've stuck with me).

She never made me feel like I wasn't wanted. Instead of making me transfer schools when I went to live with her, she let me finish at mine. She drove me all the way everyday. And picked me up. We had funny moments with that.

One day she forgot about me after school. I thought, 'Where is she? It must be 7 o'clock.' I used people's phone in the neighborhood that I knew to call her and ask where she was.

"Oh! I completely forgot!" she said.

I asked, "How do you forget the loudest thing in the house? You didn't feel uncomfortable? You didn't get uneasy?"

But she just said, "No - I came home and laid down and I was wondering what I was missing..."

"Well, it was a kid. The whole child."

"On my way!"

We laughed. She taught me self love.

I used to have self esteem problems. She would go out of her way to help me with my hair. We don't have the same kind of hair, so it meant a lot. Especially for the special days when I wanted to look nice. All the family events, she would take me. She was a life changer for me. I wouldn't trade her for the world. She's sweet and kind. Nothing happened to me there. I wasn't mistreated, and I thought it was kind of weird. 'I've been here this long and nothing bad has happened.' I was just so used to it.

A God-send.

Everyone should have a Ms. Stella.

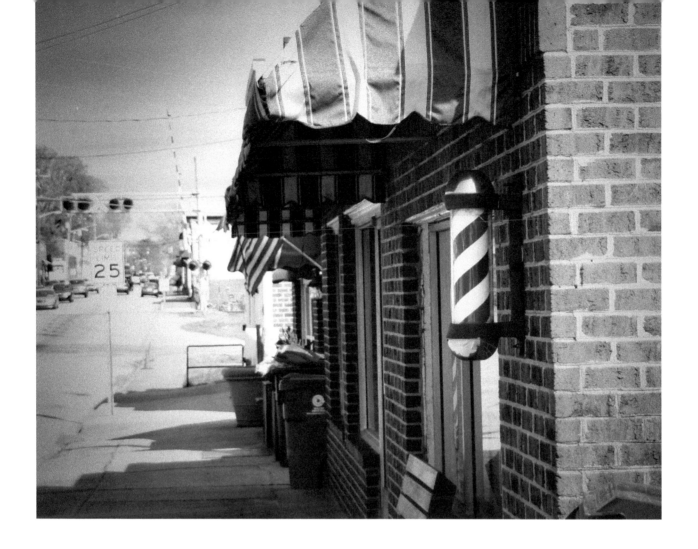

LOVE IS A SHAPE UP AND A CLEAN LINE

Our son needs to visit the barber shop regularly, but at a year old there wasn't a barber that could give him a shape up that didn't result in a meltdown.

We went from shop to shop, and each barber tried his best, but the result was the same. Then we met Mr. Alvin.

He and the guys at his shop switched from SportsCenter highlights to videos of kids singing nursery rhymes so that Andrew could relax long enough for Alvin to do his thing.

Now Andrew can't wait to go to the shop to spend time with the guys; especially Mr. Alvin.

COACH GRAVES

I've had some tough times in my life. I found a lot of relief and peace at school, especially with track. Have you ever been climbing what seems like a mountain and thought, 'I can't do it, I can't do it!'? Then, you get to the top and you're like, 'Victory! Sweet!'. Track was an outlet for me, I was so passionate about it during middle and junior high school. It helped me let go of all my problems. I had a great coach, Coach Graves, who pushed me to be a stronger person. He was a veteran and strict, but encouraging. Track was consistent and constant and disciplined. There was a hill where we practiced and it was used for training. It was serious. If I had done something that wasn't ok with Coach, he made me do bear claws up the hill. And bear claws suck. Thighs burning, barely able to breathe and all. If I was late for anything, bear claws. But as I was going up the hill, all my problems were falling off. When I got to the top, I could just focus on the fact that I did it. I did that. Coach taught me that I can't just do whatever I want without consequences and that I needed self discipline, needed to know the difference between right and wrong. He helped me learn that. With him, I was a good kid, but I didn't know what it was like in the real world, so he showed me by using real examples. 'Do you think you can talk to your boss like that at your job?' and stuff like that. I'm still late in life, but I did learn from that, really. Coach Graves is definitely significant to me because he taught me wrong from right. I joined ROTC in high school because of his influence. He helped get me straight.

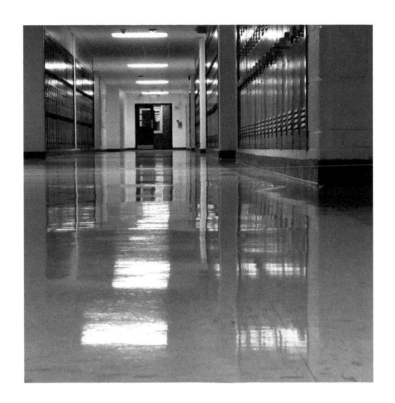

VACATION FROM HOME

School was my go-to.

This hallway symbolizes freedom for me. When I was in trouble, when no one was treating me right, I was there. I was doing 'battle of the books'. When I was in foster homes, I couldn't do my homework peacefully, but at school, in the hallways, I could do homework. I could read my books. I felt like I had all my support there. I had my teachers. My friends. It was like a way out. A vacation from home. I loved school, I still do. I learned things there.

I learned about self discipline. I was able to talk to people peacefully because no one judged me. My teachers listened. They still do, my old math teacher became the assistant principle of my high school. She was there my senior year. I will always be a Dragon, our mascot. Without school, I don't know where I would be. I learned about deadlines. I learned how to get work done. Make sure it was correct. How to be neat. I also learned what it was like to have people in your corner.

KNOW MORE. DO BETTER.

I spent many hours learning about your skin and hair care needs.

I now understand it goes beyond simple hygiene.

It's another way to love you best.

ROAD WARRIOR

As a social worker, I certainly do not work the typical 9-5 job.

I have driven through multiple counties at 11 o'clock in the evening for client emergencies.

I've awoken to emergency calls at 3am.

I've sat playing with children in an office for hours, waiting for a home to become available for placement.

I've been on-call to attend to community shelters during hurricanes.

I've also driven several hours in one day with young adults to ensure they have the ability to participate in opportunities for growth and normalcy.

Even when I manage to bypass the overtime, my work rarely stays in the office.

It becomes a part of me and often follows me home.

OPPORTUNITIES TO HELP THEM EXPERIENCE MORE IN LIFE

"If you don't get out of the box you've been raised in, you won't understand how much bigger the world is." -Angelina Jolie

HOLIDAZE

Maybe a time will come when I'm actually excited about the
"most WONDERFUL time of the year…"

LOOKING FORWARD

My favorite moments are when I can stir a
youth's excitement for their future.

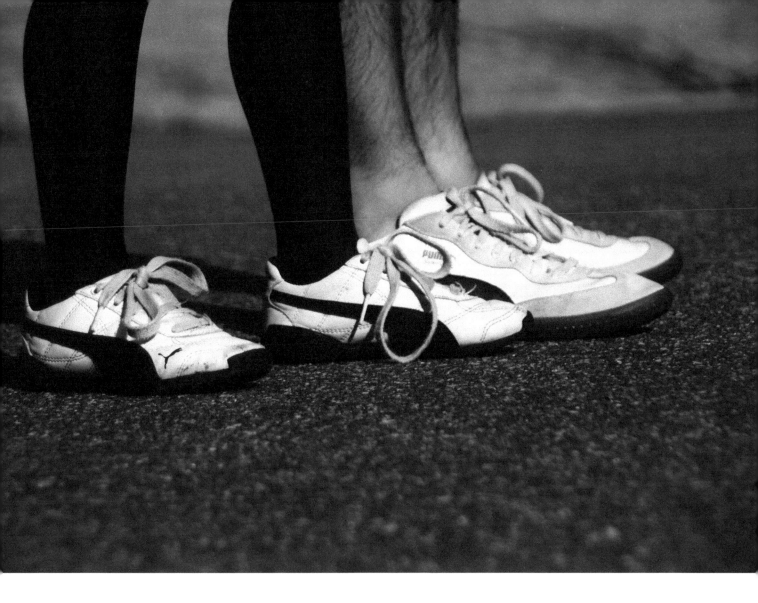

COMMON GROUND

The simplest things can create common ground when foster care introduces new cultures.
It might be a favorite TV show, time spent tossing the football each day after work,
or even a pair of gummy soled Pumas.

WHITE CAR

As a social worker I appreciated my white car. It was my mobile office, my place of refuge, a way to visit my youth and families. A way to be identified that I am here to provide support, services and resources.

At times, to my youth that white car was a way of breaching their identity, a way of violating their claim to privacy to their neighbor, school mates and others.

At other times, the white care was a safe space during long rides for my youth to share their stores without having to see the reaction on my face.

I don't know if it was the road, the cars passing by or the big open sky that allowed my youth to open up and share in the white car where they wouldn't dare share anywhere else.

Perhaps it was the peaceful journey in the morning, late night drive or mid afternoon cruise that made them share. Perhaps it was the comfort of knowing that no one else could hear or know what was disclosed in the white car, or from the relationship we had built and the peace and safety that was within the white car from all other cares and worries.

My white car was my office, lunch room and refuge on a rough and hectic day. I appreciate the white car for social workers as it is a white space.

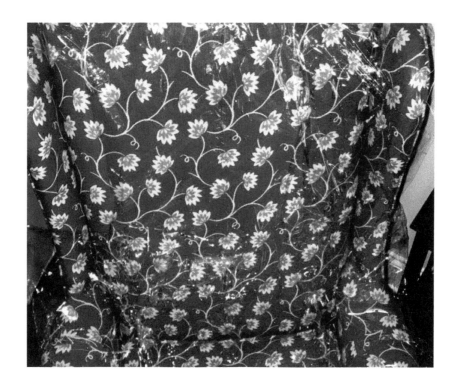

PLASTIC WRAP

To feel unwanted is a feeling that doesn't just go away because someone says that one shouldn't feel that way. It goes away when people say something and mean it. This plastic wrapped chair is recreated from a foster home I lived in. Everything felt separate. She called my sister and I her daughters, but yet so much space between us. Locked glass hutches with trinkets and dolls. I really still don't know how to make sense of it all. I no longer agreed to be a part of the fabricated idea of family within the false pretense of what "love" was. That was not love. Plastic wrapped furniture and locked cabinets - that was not love. Lying to us and telling us you could not get us decent food and clothes because the government didn't pay you enough was not love. Accusations based on other foster youth because "Oh we are all the same" … no that was not love. We were not loved. I was not loved… just unwanted.

And that's alright, but foster parents should be required to have a budget sheet to confirm expenses. Making sure that the foster youth are at the very least are getting what they need, and are safe and happy. Any youth deserves that.

LOVE

If I speak in the tongues of men or of angels, but do not have love, I am only a resounding gong or a clanging cymbal.
If I have the gift of prophecy and can fathom all mysteries and all knowledge, and if I have a faith that can move mountains, but do not have love, I am nothing. If I give all I possess to the poor and give over my body to hardship
that I may boast, but do not have love, I gain nothing.
Love is patient, love is kind. It does not envy, it does not boast, it is not proud. It does not dishonor others, it is not self-seeking, it is not easily angered, it keeps no record of wrongs. Love does not delight in evil but rejoices with the truth. It always protects, always trusts, always hopes, always perseveres.
Love never fails. But where there are prophecies, they will cease; where there are tongues, they will be stilled; where there is knowledge, it will pass away.
1 Corinthians 13:1-8 NIV

This is what love should be.

TIME IS

Time is a valuable thing

Watch it fly by as the
pendulum swings

Watch it count down to
the end of the day

The clock ticks life
away

LINKIN PARK,
"In the End",
Hybrid Theory

TIME IS

Time is

Too Slow for those
who Wait,

Too Swift for those
who Fear,

Too Long for those
who Grieve,

Too Short for those
who Rejoice;

But for those who
Love,

Time is not.

HENRY VAN DYKE,
"For Katrina's Sun-Dial
in Her Garden of
Yaddo"

MOVING FORWARD • PART THREE

The "end" of a journey through foster care is likely, thankfully, the beginning of a new journey.

For everyone, the exit is different.

Reunification can be beautiful and/or bittersweet. Adoption can be a place to find love and belonging, but it is often noted with loss. Emancipation can be liberating, but that freedom can be overwhelming and feel like a nightmare.

Leaving this field of work can be refreshing or confusing - often both.

Saying goodbye to foster children can be exciting when the outcome is safe and healing, but for foster parents, it is often a time where they experience deep loss themselves.

There are a couple of constants:

Youth don't stay in foster care forever, and their time spent in care is truly only part of their story.

Social workers don't stay social workers forever, and the turnover rate is high in this emotionally consuming field.

Foster parents don't stay foster parents forever. Sometimes they become a permanent family for youth in care and sometimes they don't.

Regardless of the end situation, everyone involved is changed by this system.

Life comes in phases.

To better understand foster care, it is essential to recognize that for all involved, it is a phase of life and not a destination.

This is a comforting thought. This part of the conversation should be highlighted, because if foster care is seen as a definition of a life - no matter what role they play in the system - we lose focus on their individual souls and their future needs.

The challenge of this chapter is to recognize "what happens next" in the transition to permanency outside of care.

BLUR

"Hello?"
Disheveled.

"dad..?"
Alone.

"Adulting?"
No Guidance.
Lost.

"MOM?!"
Alone.
Resilience.

"family..?"
Patience.

"okay."
Journey.
Thrive.

Am I doing this right??

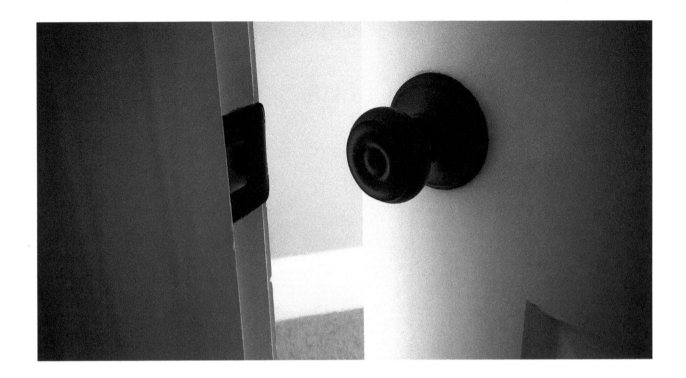

THE INTRO TO REAL LIFE - ME EXITING CARE

This was a door to a whole different world I didn't know about yet. That doorknob symbolizes the intro of a new world, the "real world". I was signing out of DSS and wouldn't be receiving any more support from the state system. I would've been put in a group home and A'aydin would've been put in foster care and maybe adopted. My social worker wasn't trying to support me having a kid. She was doing everything she could to make me get an abortion, but it wasn't happening - so I had to find a place on my own. I was essentially homeless for several months before I moved in with Crystal and Jeffrey. I had to trust these new people with my life, because I didn't know them from Adam, I didn't know them from a pail of paint, nothing. Not much difference in fostering, but this was my choice. I trusted them because I wanted the best for my son, but I couldn't know their real intentions. I feel like the light in the picture is like my new life shining, saying "Trust it or don't trust it." I'm glad I did. My son's healthy, he's fine, he's good. They taught me everything I needed to know to be on my own. I got my first car with them, my license, everything. They're my son's godparents. Without them I don't know where I'd be. They allowed my son to stay with me, because if I would've stayed in a foster home we would've been separated. That's not all cases, just the foster parent has to be willing to foster the kid, and then that kid's kid.

GOING HOME

The day came for our foster daughter to be reunified with her family.

This is what we prayed for her. We wanted her to be back home. We felt genuine joy!

However, the joy we felt was equally matched with mourning. We were saying goodbye to a child. I dropped her off at her home and drove away with tears filling my eyes.

The road ahead was blurred.
Would we ever see her again?

Would she think we abandoned her? Will she be safe?

I knew it was the right place for her, so I felt guilty about my own grief. But, I knew it wouldn't have been better if I felt nothing.

If I didn't mourn losing a child, then I must never have felt like she was my child. So I am grateful I felt the pain. It meant when she was in our home she felt the love of a mother. My heart can handle feeling broken, because her heart definitely deserved feeling loved.

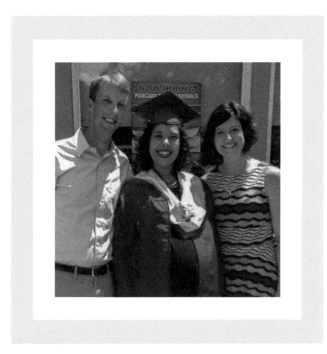
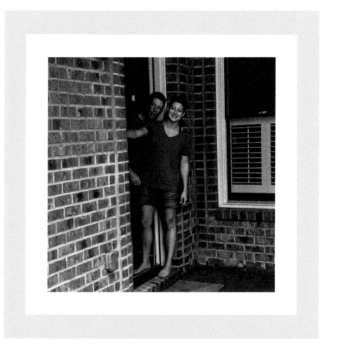

THE WEST

When I was pregnant and homeless without anywhere to go, Angel, my Guardian ad Litem (GAL), basically sent out emails trying to find me a place to stay. I remember thinking, 'Forget it, no-one's going to take me, I'll be homeless, it's whatever'. Three families responded to Angel's request, but not all of them worked out.

After a few interviews, the West family became my last placement. As soon as I got to their house, as soon as I got in the garage, I knew immediately that this was where I was supposed to go. They came out and hugged me and we talked. They showed me around the house, showed me that the downstairs would be my area. There was a door where I could go in and out as I pleased, so it wasn't like I was imprisoned or anything. The room was huge. It was a nice, peaceful environment.

We were talking and I chose them immediately, I thought, 'This is where I'm going'. I signed the paperwork over April 1st, 2015. I thought I was going to unload my stuff myself, but they actually helped. They said things like, "Don't touch a thing, we'll do it. Just go in there and show us where you want us to put stuff". I had my own space.

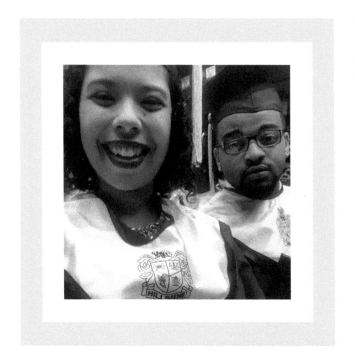

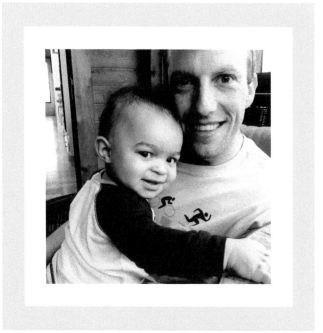

I remember driving up that first time, them looking out the window. It was ridiculous how excited they were - I made them recreate the picture, but that's literally how they were. They helped me out and ever since then, they've been very special to me.

I wouldn't be where I'm at without them. I probably wouldn't have graduated high school. The Vanderbilt's. I hope everyone can find a family like this. You don't find many people who are willing to take a "troubled kid", not knowing anything about them except that they're pregnant. They didn't once say, "you made a mistake". Not once.

They loved me like I was their own.

Everyone needs people like that in their life. They included me in family pictures and events. They took me with them on vacation to the mountains. I loved it. Jeffrey helped me into the career I wanted. Everyone needs that type of love and support in their life. Evelyn and Owen are lucky to have them. They will go above and beyond to make sure their kids are good. I'm lucky to have them and so is A'aydin. For them to even be a part of your life, you're lucky. To even just walk in the grocery store beside them, you're lucky.

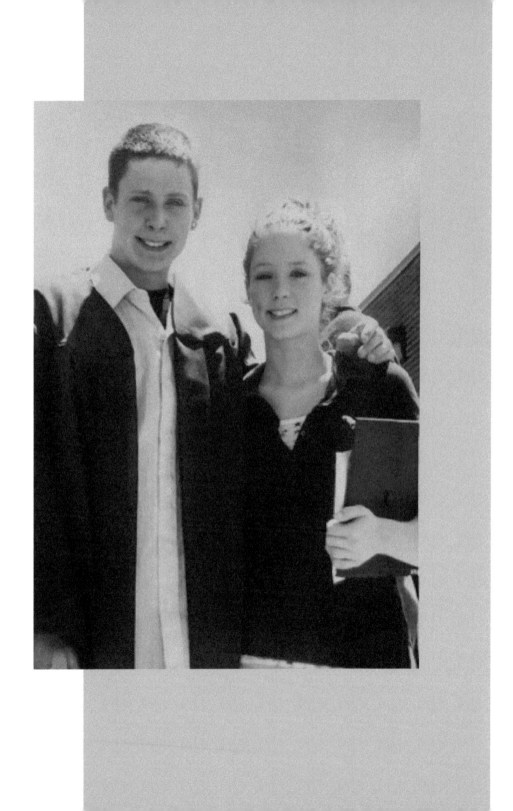

SCHOOL ACTIVITY
PARENTAL PERMISSION FORM

ACTIVITY: _track meet_____ DATE: _04/01/2010___

___Brother_____ has our permission to attend this school sponsored activity. We understand that school sponsored activities are not counted as absences. We also understand that students must have assignments completed and handed in prior to the activity, or other arrangements must have been made with the teacher(s) involved prior to departure time to receive credit for work missed. For additional information regarding Make-up Work Guidelines, please see page 8 of the student handbook.

STUDENT SIGNATURE: __17 y.o. brother_____

PARENT/GUARDIAN SIGNATURE: __20 y.o. sister_____

*please see attached custody paperwork
thank you!*

KINSHIP CARE

When Older Siblings Step Into Parents' Shoes

DISTANCE

Believe in the success of Foster Youth, no matter the age.
Breaking statistics and overcoming suppressed rage.
Not the easiest thing to do for many but that doesn't
mean give up on them for a few more pennies.
Give foster youth hope.
Don't assume that if they mope
That somehow it's personal
Think before you speak
Don't poke and pry into a foster youth's life
Then tell all your friends
And not expect them to cry.
Because the next thing you ask,
Foster youth may lie or
Begin acting shy
Don't say they're acting funny
And exchange them for another
Did you think that maybe they should see their brother?
Or sister? NO. Perhaps not.
You told them to get their grades up- and they did not.
So as a punishment you made it?
Ha. Like that helped a lot...
"Mo money, Mo problems"
But if this one acts up, just send them away.
You'll get a new one, like cattle- and oh the incentive?
More money, new face and new hair
They call it "Therapeutic foster care"
I've seen many horrendous lives
Destroyed beyond my eyes
Too many meds and you think you're helping
Not enough love and wonder why they're constantly yelping
Yelping for love, attention and for someone
to believe in what can be achieved
But maybe that someone, that family, that piece
For the hole within their chest
The gaping sore that goes beyond all the rest
Is just in the distance, waiting to be found
Or maybe it's right there in front of them
Silently waiting around

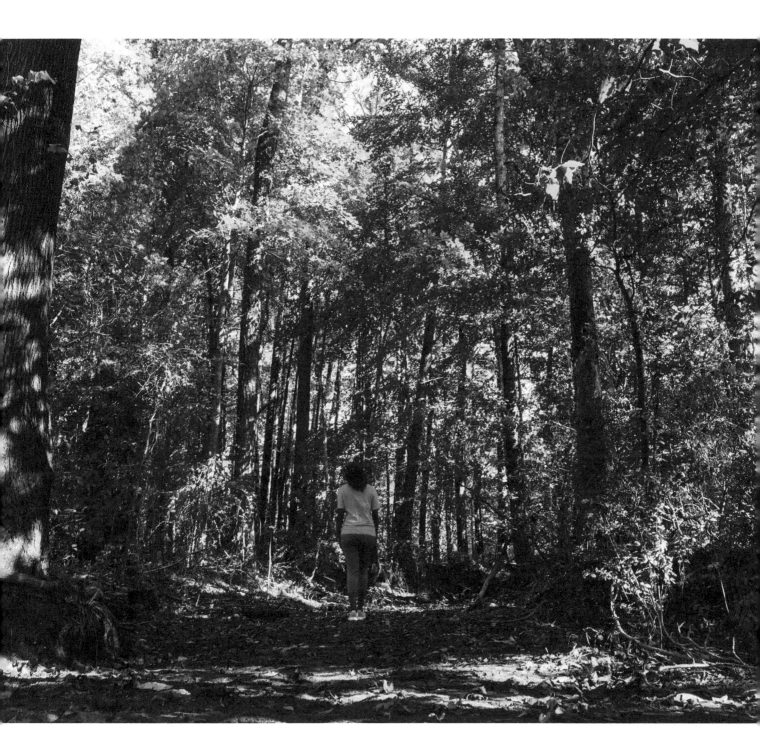

I FOUND MY PASSION...

Through LINKS & SaySo I found my professional niche that could sustain me for decades. The field of social work has endless opportunities, but helping youth in foster care find their voice through opportunities, experiences, knowledge, leadership and advocacy are like fitted pieces to a puzzle.

"Some say life is like a box of chocolates.
I say, life is like a PUZZLE.
You and I
are the pieces.
If one piece is missing the picture is incomplete.
Making things
- relationships, disappointments, let downs, set backs, loss -
a little harder to solve.
Who would think
a piece so small
could make such a difference
- or an IMPACT, I should say -
We need you.
It is time to get into your position -
To figure out what part you are or where you belong.
GET THERE.
Because you matter.
You are a piece to the puzzle.
NOW, PLAY YOUR PART"

Jackie G-Pittsburgh, PA

KEEP STATISTICS AWAY FROM YOUR DREAMS

Indignation and fear circulated my mind as I carried the printer up the stairwell to the motel room where I had been living for over a month.

The printer knocked against the side of my leg with each step as I struggled to carry it. I could not obtain a pass for on-campus printers because I did not have an address to list on the required paperwork.

My thoughts grew louder, "I cannot afford this printer. Hush! You have no choice, it was a purchase of self-preservation, and this is survival". I would have to reconcile the monetary repercussions later.

I was a month into a competitive and accelerated program at The University of North Carolina, at UNC Chapel Hill, where I would earn my master's degree in 12 months. The summer sessions were described as an intensive course of study, with eight hours of class each weekday and I passed nights in the motel room completing assignments.

I shook my head at the irony of being accepted into one of the top three social work programs in the nation, yet here I was living in a crime-ridden motel just praying I had enough money to stay.

Despite the statistics that come with aging out of foster care, despite the fact that I failed 9th grade, transferred high-schools five times over nine placements, spent my adolescence involved in thejuvenile justice system, including nine months in a detention center, undergoing mental health therapy by age 16, and being mandated to live in a therapeutic foster home my last two years of high school - despite all of that, I found myself at UNC.

By grace, I had managed to graduate high-school on time, while working 30 hours a week, and with a GPA high enough to get into a university. I rented an apartment before graduating high school to avoid becoming homeless upon graduation, paying the rent with my five dollars per hour earnings

and hiding this lease from my foster family and child welfare workers until after graduation.

I graduated from university five years later with a 3.4 GPA and 4.2 years of work credit in the public employees' retirement system.

At the age of 20, I had purchased an older mobile home nestled in the Appalachian hills of Southeastern Ohio - thanks to a high school teacher who allowed me make payments as I had no credit nor co-signer.

In my early 20's, I was granted kinship custody of my younger brother and provided the best care that I could for him.

I share these feats not to boast, but to challenge the moral judgement in this country which assumes that a person living in poverty is poor through some fault of their own. Only to then use that moral judgement to further determine whether someone is 'deserving' of assistance.

Labels are applied from the top-down, towards those living in poverty by those who are not, all too often failing to consider the social structures which underwrite poverty.

I was intelligent, driven, and accomplished.

Life was not easy, but I was determined to practice the middle class art of sacrifice for the sake of deferred gratification.

By moral judgements, I had made all the 'right' choices in striving toward the American Dream: I had went to college, worked very hard in my employments, did not use drugs, and avoided having children too soon.

So how in the world did I end up homeless, living in a crime-ridden motel, attempting to excel in one of the top graduate schools in the nation?

It was my final semester of college and I had Good Friday off from work, I had spent the day preparing graduate school applications. The day's relaxing bath was cut short when I experienced a stabbing pain in my shoulder blade. I sat on the bed hoping the pain would pass, but it increased and soon I became short of breath. I went to the Emergency Room where I was diagnosed as having a spontaneous pneumothorax, a collapsed lung. I went home and the hospital bills came.

Students with chronic health conditions or catastrophic illnesses know that student health insurance is not sufficient at covering costs. I immediately went back to work with the resolve to pay off medical bills, as I had done numerous times before.

I had never earned above the federal poverty line and so I borrowed additional student loans over the course of my undergraduate career to cover the cost of medical care not met through my student health insurance. The lung collapsed again a short time after graduation and I was transferred to a regional hospital, as the local rural hospital did not have a lung surgeon.

While in this regional hospital, I was informed that because I did not have insurance, I was not a candidate for surgery, so I had the same Band-Aid procedure to inflate the lung and passed another few weeks hospitalized. (continued)

...DREAMS (CONTINUED)

I deferred entrance into graduate school and accepted a job at the university, a job which kept my hours just below those for full-time employment to avoid paying benefits, but at $13 per hour, I was grateful for the job as it was coveted just to have a job in a county with a poverty rate of 32%.

Over the course of the next three years, I experienced eight more lung collapses. The left lung completely collapsed again the following year. At the age of 24 and with no health insurance following graduation, it was my saving grace when a regional hospital with charity care had since hired a lung surgeon.

I underwent pleurodesis surgery to prevent collapse from reoccurring and was discharged from the hospital after a three week stay. I returned to work the next week as time off is not an option for those with no support system or safety net resources.

Two months later the lung collapsed again, on the same day I was set to start a new job, an interview I had landed while hospitalized previously. I had completed the application with tubes hanging out of my body in all directions, because life doesn't stop if you're sick. I called and apologized to the employer that I would have to back out of the job offer as I prepared for a second surgery on the same lung.

Quality healthcare is not readily accessible in rural America, I learned later that my first surgery did not go successfully as it should have. A year passed and I was confident that the following year I would be able to enter graduate school at UNC Chapel Hill, my dream.

Three years from the start of lung troubles and set to begin graduate school the following month, I felt a "pop" in my chest while walking from my car into work, this time in the right lung. I knew immediately. I talked of treatment options with the man who had become "my" charity-care-lung-surgeon as he showed me a CT scan of my lung dangling in my chest cavity like a deflated balloon. I immediately opted for surgery this time.

Though the pain of lung surgery is immense and recovery harsh, I was determined that I have living yet to do. I deferred my entrance to graduate school for yet another year.

What happens to a dream deferred? My health, my credit, and my resume were wrecked. I received bills for 60k+ for the surgery in the mail, dozens of separate bills for x–rays, bills for contracted services such as laboratory, pathology and numerous physicians. Hospital charity care programs assisted with the cost of surgery but do not cover contracted services so those went unpaid.

Finally, four years after I anticipated going to graduate school, I was healthy enough to do so.

I knew that my credit was poor due to unpaid medical bills, but I did not realize the extent to which it would become a barrier to housing as I had 7+ years of good rental and ownership history and had always been responsible with money.

Before leaving for graduate school, I sold my mobile home for $7000, as I knew I would need this money for school. I did not anticipate needing it as a vital lifeline to rent a motel room because I would not be able to secure housing in a town as well-resourced as that of Chapel Hill.

At the age of 30, I am still paying for my health history. I am working to rebuild credit and pay back the student loans I used to cover the cost of healthcare while in college.

I am hopeful though as I meditate on the newfound stability I've encountered since completing my master's degree and clinical licensure.

Despite my difficulties, I know I am privileged to be a part of the 30% of former foster youth who graduate high school, 3% to graduate college, and less than 1% to earn a master's degree.

Every day that I go to work, I am grateful for job that I love, working as an Integrated Primary Care Behavioral Health Consultant in an FQHC.

At home, I enjoy just listening to the sound of the clothes dryer. It's been my marker for success, a representation of the stability I have worked so hard to achieve. Preparing a home-cooked meal, drinking my cup of tea in peace, having 'family art hour' or going fishing with my grown siblings and their kids, and throwing the ball to my dog. These are the things that make my world go round and I love the 'boring' simplicity of it!

Nowadays I reminisce as I drive by the Red Roof Inn in Chapel Hill, always careful to mutter a prayer for continued health, as I have so much yet to do and much to be grateful for.

I am the human face of foster care.

I am a human face of healthcare policy.

I am the human face of homelessness.

I am the human face of the Deferred American Dream.

More important though,
I am the human spirit of resilience.

A'AYDIN NOEL

A'aydin is my baby.
He's my life-changer. He gives me a run for my money.
He's everything to me and more.

I got pregnant with him unexpectedly and my life changed. I didn't know what to do.
I didn't know what it was like to be a mom. I was just trying to graduate high school.
I remember, I thought I had the flu.

I went to the wellness center at school. I had been in ROTC class and kept feeling sick, throwing up. The nurse asked me what was going on, so I told her. The people at the center said, "We're going to give you a pregnancy test." I said, "I don't know why you're going to waste the test, that's a waste of money. I'm not pregnant." But after I took the test, they came back out with a brochure that said 'Options'. I thought she came out with the wrong paper or it was something to take notes on. Nope.
She started talking to me about 'options'.

I was like, "No, that's not right. You have to do it again. There's no way that was my pee. You mixed me up with someone else." So they did it again, and it came back positive. I called my social worker; she was the first one that I told. Ms. Stella, my foster parent at the time, was the last one that I told. I was scared about what she was gonna say. My social worker came and wanted me to get an abortion. I could say she strongly suggested or wanted to force me, because she even drove me to a clinic one day that did abortions, but I refused. I didn't want to take the pill.

I was pregnant my senior year of high school. I was sick the entire 9 months.

I moved in with different foster parents, Crystal and Jeffrey, when I was 7 months pregnant and I know I graduated high school because of them. At 7 months, I was still trying to squeeze into jeans that weren't fitting anymore because I didn't have maternity clothes. So Crystal went and bought me maternity outfits. I was 9 months pregnant walking across the stage for my high school diploma. It was two weeks after I graduated high school when I had A'aydin.

Don't get an abortion. If you don't want the kid, you can give him to someone who can't have kids.
Don't end another life because you think your's is gonna be ruined, it's not. He's the best decision I ever made. He's 100% the best decision I ever made, and I wouldn't go back if I could.
Don't give up. If you are a single parent it'll be ok. I'm making it.
Terrible two's and terrifying three's really do exist.
Stick it out and pray. I wanted to make sure he had the best life.

I didn't want to give up on him like people gave up on me.
He was just a baby. He didn't ask to be here.

Everything happens for a reason - God knew I was going to get pregnant. He knew what He was doing when He blessed me with A'aydin. That was the life-changer I needed. "She needs this kid." He planned it out, He knew. If you get pregnant and it's a tough time, keep pushing forward. Keep the baby. They're a blessing in disguise. You may think "Oh, now I'm pregnant - I don't know what I'm going to do," but it comes naturally. I didn't have motherly instincts. I didn't think, "How am I going to bond with something that put me through all this pain?" But as soon as he came, I had that bond. Wouldn't trade it for the world.

SUN FLOWERS

As I look upon my life, I see the highs and the lows. The bright summer days that were filled with cloudy storms within my life. Living in the warm and ever so inspiring California weather - I still could not fathom a day in which my life would actually get better. I did have hope but through the years it began to whither. It's as if some days I knew I'd be a success and others I was suffocating in a seemingly inevitable doom. As I passed through my grandmother's garden as a child and looking at all her flowers and plants that she taught me to grow, I would think about how simple life would be as a flower. Now, as I am nearing in age at almost half a quarter of a century, I realized that I am not doomed. Life just is hard sometimes, but if you allow your light to shine bright enough, you will acknowledge your own ability to be fruitful. If I were a flower, I'd love to be a sunflower. I never see people crying with sunflowers. Their petals are bright. They move with the sun. Just as I do. With each dark night brings forward a rising of the shining sun. A brown girl that has blossomed into a queen with the help of many bright and loving stars. The ones who took me in and held me on days I cried within their arms. I'd shed those scars and heal from within. My light grew from sparks to flames - and still today without an end. As sun flowers absorb the light, they illuminate a light to others. A sun flower. I am a soul flower. Bright. Beautiful. Memorable. And above all, nourishing to the soul.

A DAY FOR JOY

All of our adoption paperwork was submitted and we were left to wait for the official Adoption Decree to come in the mail.

The journey to this point had been filled with many emotions, as I have learned that adoption is more complicated than I thought. It's a beautiful thing to see the joining of a new family, but we also acknowledge its deep roots of loss.

In order for a child to join a new family, he must first lose a family. I mourned this loss for him as a baby, and I will walk beside him when he understands and mourns it himself.

But, I sat waiting for the mail each day with a heart full of joy. A joy I have for his life story that will not be decided by a past of brokenness. I won't dismiss his past, since that would be dismissing part of who he is, but I will choose to focus on his future.

After wrestling with these emotions, finally, the day had come. When I opened the mailbox, the sight of that large manila envelope sitting inside released an audible gasp from my mouth.

It was here. The piece of paper that proved our son was officially our son.

I held him on my lap as I read through the decree with tears streaming down my face. In my heart, he was my son a long time ago. But having the legal paperwork to justify that feeling, provided me with a huge relief.

Every child deserves not only to be loved, but to be deeply wanted.
He is deeply wanted by us. So his was a day for joy.

YOUNG ME.

ME NOW.

This is my truth:
*"For you were once darkness, but now you are light in the Lord.
Live as children of light..." Ephesians 5:8 NIV*

A BRIDGE TO CONNECT

Our adopted son's first family is a connection we will always cherish and nurture. It was intimidating at first to reach out and start building that bridge. We had our fears and doubts. But, we knew he needed to grow up knowing where he came from and how his story began. So we reached out a hand and it was returned with warmth and appreciation. We came to find out that our family had grown through adoption in unexpected ways. We knew we were gaining a son, but we happily discovered we were gaining new sisters, cousins, aunts, and grandparents as well. This beautiful bridge of redemption was built, as we both put aside judgements and assumptions, and allowed the selfless love for a child to prevail.

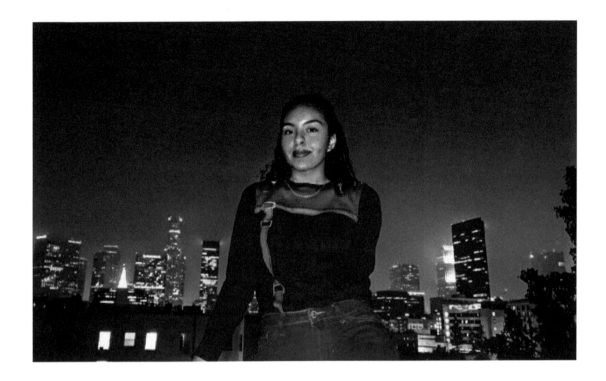

L.A. ROOFTOP

What does it mean to succeed to you?

Is it easily labeled by the cliche of going to college followed by an excursion of unlimited educational milestones to a doctoral degree? Is it the white picket fence, lavish outings and marriage with 2.5 children? Is that truly the goal?

Well, for some, but for me it's not exactly in that order. My life has been a sum of one of a lifetime experiences, travel, trauma, healing, intense love, and many, many lessons. Some say I have reached success already, but for me there is always another rock to discover, another idea to be birthed, another feeling to be understood and another breath to be meditated upon.

Life is a journey, not a destination and there is never a true end with success, if you set your mind on it.

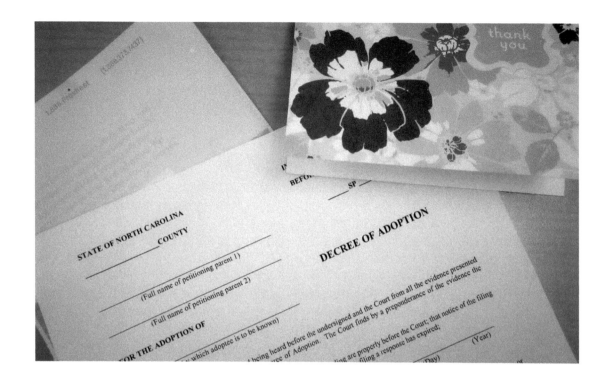

FOREVER HOME

When a youth gains a permanent home- through adoption, guardianship, or a successful and safe reunification- I feel all my work has made some positive impact.
These joyful endings are what I seek for all my youth.

FOR THE STORYTELLERS

Who are you without your story? Paralyzing thought, isn't it? To know who we are away from social constructs, job titles, relationships and traumas. We fear there will be nothing left of us, so we cling to who the story says we are. The trouble though, our spirit withers if it stays here. Slowly we must start living again at no named place, there is no right time. Draw a line in the dirt and step over it. That line asks us to reject the fiction that tells us that the worst things that have happened to us will write the rest of our story. We start the work to integrate the traumatic experiences into a meaning of moving forward. You start with a whole handful of nothing and ask yourself what will I need to bring with me on this life walk forward? Ask how will I bring pleasure, joy, and wellness to my life? Who can I trust to enrich my life and help me develop? Healing does not ask us to pretend 'it' never happened. Healing incorporates 'it' into who you are, your future, your liberation. Healing is found in the development of new identity structures to replace those damaged in our past. Healing happens when we construct new patterns of behavior that begin to reflect a deep sense of who we are. Most essential, Healing does not have a final destination. We return to greet ourselves time and again to take our own hand for another wander through the healing labyrinth. During life's unstable moments which bring us to our knees, we must remind ourselves that if we keep going, we take the story a bit further. By rejecting the fiction told to us by our past stories, we begin to live our truth. As our truth expands to fill the space we give it, we become a passersby to the limitations our stories have created and we see for the first time, we are so much more than what has happened to us. Write your story.

SCULPTURE BY DIANE, SARAH'S MOTHER

BLESSINGS OF A BROKEN ROAD

The foster care road is broken and winding and the destination is unknown.

The feelings of pain, sorrow, and hopelessness are littered throughout, but the glimmers of love and hope consistently break through.

The cracks in the pavement are there, but the road perseveres.

The winding path, though exhausting, develops endurance.

The unknown destination, encourages faith.

And as you begin walking down this road you see there is a guiding line. It's sometimes faded and hard to see, but it's still there. A line of hope that runs right down the middle.

The hope that relationships begun from brokenness, will be redeemed.

The hope that seeds planted will be harvested tenfold.

The hope that love felt from unexpected people will point many hearts to our Heavenly Father who loved them first.

That's why we do it. And it's worth it all.

FOSTER CARE WAS ONLY THE START OF MY JOURNEY.

SPECIAL THANKS

Our heartfelt gratitude goes to those who have made this initial endeavor possible through wide and various support.

Vernon and Nan, Dan and Amy and their family, Sam and Deborah, Chip and Margy, Glenn and Mary Lou, Ed and Kathy, Paul and Gail, Abbi T., Mark and Sharon and the staff and members from our family at North Ridge Christian & Missionary Alliance Church.

Especially Elizabeth, who made the exposition of this book possible.

WHAT DO I DO WITH THIS BOOK?

I heard this question being asked long before we sent the pages to print.

A logical, sincere question that is likely motivated by a heart broken by the words contained within this book.

The truth is, I don't have a simple answer to that question.

As a believer who holds to the truth of Scripture in the Holy Bible, I believe that Christ came to redeem mankind and that there will come an end that allows us all to be at complete peace. But we're not there yet. Right now, we're in the brokenness - if you're also a believer, you know we are 'in the world, but not of it, set apart for His will'. The Bible tells us that we are called to live and love the world around us, even in the brokenness.

So, I want to encourage you in that. Not to try and be the solution, as that alone is found in Christ - but to be a voice through which people can hear Christ. To do what He calls us to do, to love the people around us in prayer and word and deed.

There are some very clear, tangible ways you can impact the story of foster care:

☐ *take care / be mindful of your neighbor* Everyone has a story. Before anyone enters foster care, they are a part of a family unit. If there is any opportunity to intervene in love, perhaps introduce people to Christ before crisis, that is an ideal way that everyone can impact the sphere of foster care. Create safe connections within your community for families invovled with foster care

☐ *love a foster CHILD in your circle of influence* (pray for, listen, help - get to know them, take an interest in their lives, talk to them, go watch their sports/school activities, etc.)

☐ *love a foster FAMILY in your circle of influence* (pray for, listen, help in any way)

☐ *donate items or finances to reputable charities that work in foster care* (it's a bonus if you can be involved physically, as well)

☐ *recognize that a large portion of those incarcerated were once in foster care, and show them compassion when the opportunity arises*

☐ *recognize that a large portion of the homeless population were once in foster care, and compassionately bring that narrative into your interactions*

☐ *become a foster parent or adopt a child* Fostering and/or adopting a child is not something everyone is called to. However, we believe everyone is called to 'something'. Prayerfully consider what you are called to do specifically.

☐ *become an advocate* Learn what your state laws are regarding foster care, get connected to advocate groups

☐ *continue learning* This book is challenging and the time you took to purchase and read it is not lost on us. There's a reason this book came to be with you. There's more to the story.

The organization behind this book, Empty Frames Initiative, looks to empower orphaned and vulnerable youth as they transition out of state care. The proceeds from this book go to that mission. If you feel led, please share and promote this project.

This book was an opportunity for some of our authors to reflect on what was and move into what will be. Empty Frames Initiative looks to do this with young adults going through our future programs.

It's not always about explaining the journey to others - it's about what happens in the process.

As you explain your journey to others, you explain it to yourself. You identify how your perception has changed since the story was last told, or how you've grown since you went from point A to point B. As you see in this book, stories are powerful.

When people are given the opportunity to speak and when others listen, lives are changed forever.

You can help us do more of this.

Thank you for reading,

- Miriam & the Empty Frames Initiative Team
www.fillingemptyframes.org

CPSIA information can be obtained
at www.ICGtesting.com
Printed in the USA
BVHW090845120522
636874BV00020B/419